How to Paint
LANDSCAPES

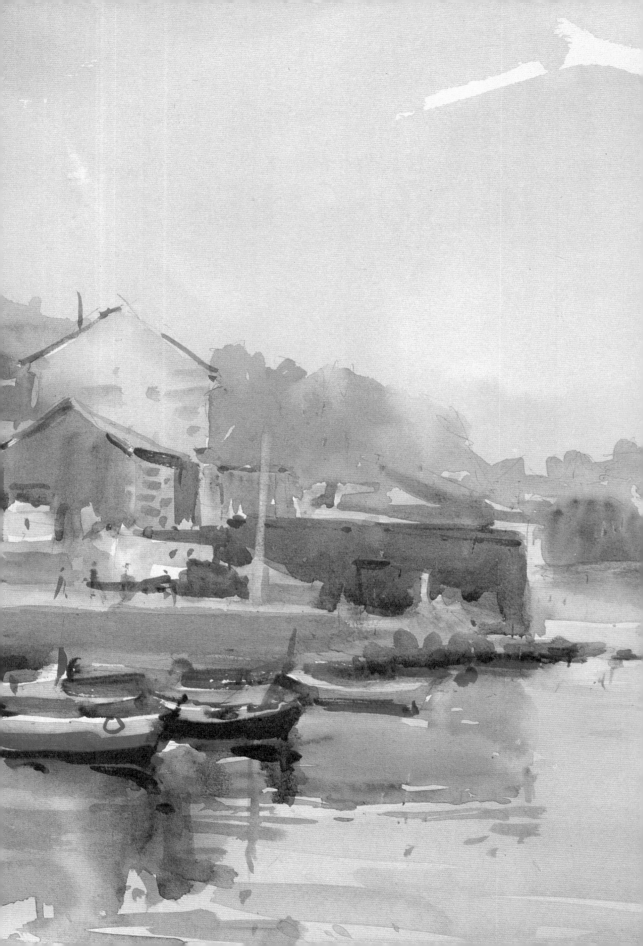

How to Paint
LANDSCAPES

José M. Parramón and Julio Quesada

Watson Guptill Publications/New York

Content

Introduction, 6

The great masters of watercolor landscape, 9

Albrecht Dürer, 10
Van Dyck, Lorrain, Poussin, 12
Gainsborough, Sandby, Cotman, Cox, 14
Turner, Girtin, 16
Constable, Bonington, Peter de Wint, 18
Delacroix, Fortuny, Harpignies, Palmer, 20
The impressionists, 22
Painters influenced by Homer and Sargent, 24

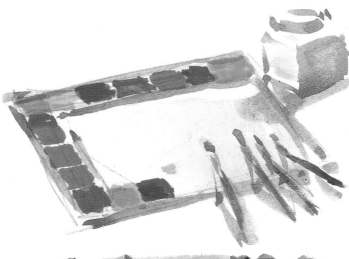

Materials, 27

Studio equipment, 28
Paper, 29
Materials and tools for drawing, 30
Brushes, palette, watercolors, 32
Equipment for painting outdoors, 3
Painting quick sketches, 36

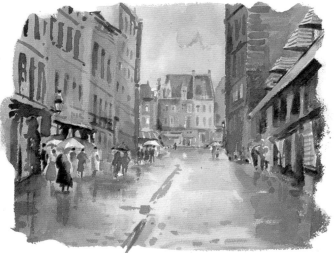

Drawing, the basis of painting, 39

Dimension and proportion, 40
The fundamentals of perspective, 4
Perspective is necessary, 44
The leading grid, 46
Atmospheric perspective, 47

013464

Color theory and practice, 49

All the colors of nature with three
 colors, 51
Color and contrast, 52
Painting with only four colors, 53
Mastering a single color, 54
Painting a landscape with two
 colors, 55
Painting a landscape with three
 colors, 58
Harmonizing colors, 62
The colors Quesada uses, 66

Interpretation and synthesis, 69

The teachings of the impressionists, 70
The process of interpreting and
 synthesizing, 72
Interpreting different subjects, 74
Skies and reflections in water, 76
Quesada's trees, 78
Quesada's figures, 80

Painting landscapes, 83

Quesada's techniques, 84
Painting watercolor notes, 86
Painting a Majorcan landscape, 88
Painting a seascape in watercolor, 90
Blue and sienna, 92
Construction and reflections, 94
Covering over "holes," 96
Painting a seascape in watercolor, 98
Contrast, 100
Structure, 102
Balance and synthesis, 104
Painting a landscape with houses
 and a beach, 106
Mixing colors on the paper, 108
Atmosphere, 110

Acknowledgments, 112

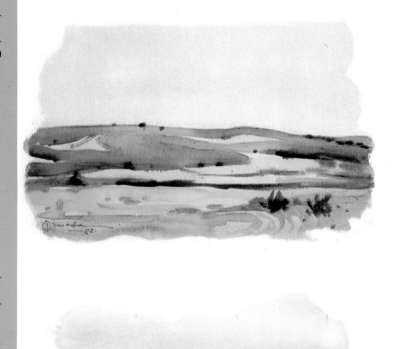

Introduction

Figs. 1 to 3. Julio Quesada in his studio, at his easel, surrounded by his paintings. He also plays the piano brilliantly, sometimes composing his own works.

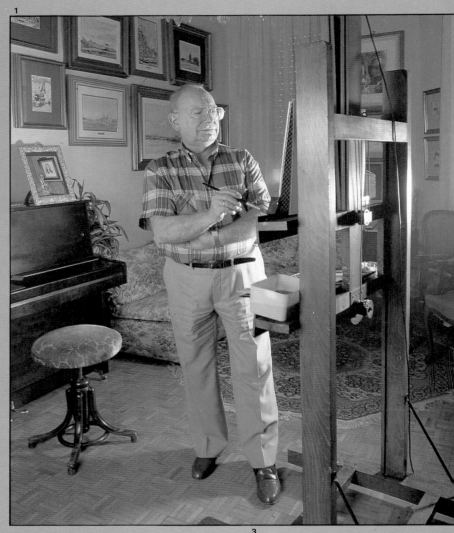

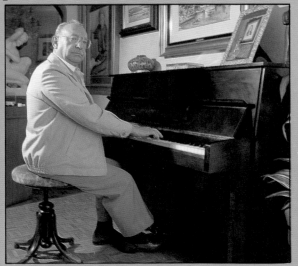

To paint a landscape is to know and experience nature—the countryside, the mountains, the trees, the grass, and the sky. You take into your senses the splendid blue of the sky, the fascinating reflection of water, the smells and colors of the earth, of grass, of life!

And this coexistence with nature is even fuller if you are painting in watercolor, because to paint in watercolor you have to paint impressions, interpret, summarize, and abbreviate. To scale the heights and achieve a good watercolor in which you really see the water, the light, the color, you have to transform nature into a synthesis of form and color.

In this book, we offer you the chance to experience the great adventure of painting nature in watercolor by seeing how it is done by Julio Quesada, a famous teacher and artist, an expert in the art of painting landscapes in watercolor.

First, we will discuss, through text and illustrations, the pioneers and masters of watercolor landscape painting, from the German Albrecht Dürer and the Flemish Sir Anthony Van Dyck to the American John Singer Sargent, not forgetting the English artists Paul Sandby, John Sell Cotman, David Cox, J.M.W. Turner, Thomas Girtin, Richard Parkes Bonington, Peter De Wint, Edward Seago, and many more.

Then we will get down to business, showing you the materials and methods Julio Quesada uses to draw, sketch, and paint landscapes. We will show you the easels he uses in the studio and in the open air, even the miniature paint boxes he uses to paint quick watercolor notes. Then we will go on to discuss the range of colors Quesada uses in his paintings, as well as the types of paper, brushes, and palettes. Before dealing with the basic techniques of drawing as applied to landscape painting, we will discuss such subjects as structure, perspective, and atmosphere.

Following this, a special chapter will be dedicated to color theory and handling, with discussions of the primary, secondary, tertiary, and complementary colors. In this section, Quesada will give you a practical lesson on the possibilities of painting a landscape using just the three primary colors, showing you how all the colors in nature can be achieved from them. Next, we will continue our discussion of the colors Quesada uses, paying special attention to his technique of painting in a range of broken, or grayed, colors. You will also see how Julio interprets and synthesizes form and color (a style that has made him justly famous); then you will study his techniques in painting wet on wet, mixing colors on the support, and reserving and opening up whites.

Finally, in the last section of the book, Quesada will paint two notes and three landscapes, allowing you to follow their development and resolution through the step-by-step illustrations that are included.

Julio Quesada is the ideal person to reveal the secrets of this process. In addition to being an accomplished visual artist, he also plays the piano with extraordinary ease and has even composed several pieces. He always listens to music while he paints—"Debussy is my favorite," he says. As an artist he is well known all over the world, with paintings in prominent museums and galleries in Europe and America. He has won countless first prizes, medals, and trophies for his figure paintings, portraits, seascapes, and watercolor landscapes.

José M. Parramón

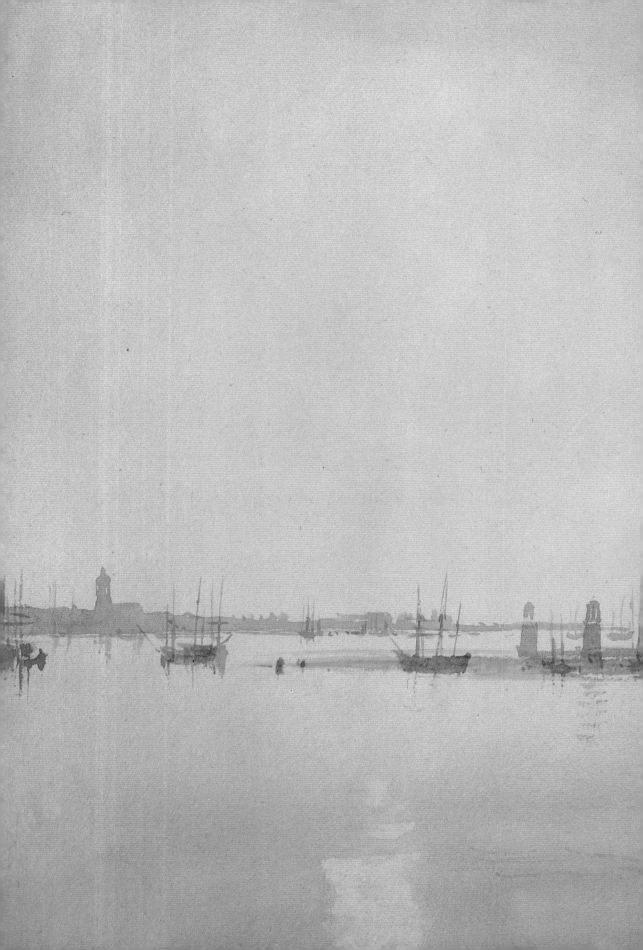

THE GREAT MASTERS OF WATERCOLOR LANDSCAPE

*T*he earliest known picture by Albrecht Dürer, painted in 1489 when he was eighteen years old, is a watercolor landscape. Dürer is well known as a pioneer in watercolor painting. He was followed by Van Dyck and later by Claude Lorrain and Nicolas Poussin. The latter two artists, who transformed their one-color watercolor sketches into great oil paintings, brought about a renaissance of the watercolor in England that was led by Paul Sandby, followed by the likes of Turner, Girtin, and Bonington. In fact, the watercolor was already well established by the arrival of the romantics and the impressionists—Eugène Delacroix, Paul Cézanne, and Vincent van Gogh—and the Americans James Whistler, Sargent, Edward Hopper, Homer Martin, and the British Seago. These are just some of the great masters of the watercolor landscape whose works you can admire on the following pages.

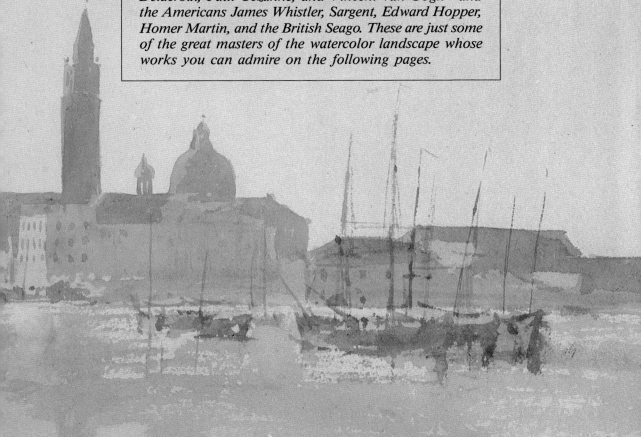

Albrecht Dürer

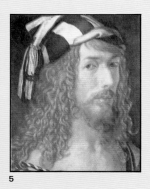

5

"Art is implicit in nature, and he who can capture it, possesses it."

These are the words of Albrecht Dürer, revealing his attitude to the world about his work. In and through this point of view, he explained his thirst for knowledge, the need to infuse his work with his powers of observation, and his efforts to capture and depict everything he saw.

Albrecht Dürer was born in 1471 in Nuremburg, Germany, the son of a goldsmith who nurtured in him the love of art and beauty. He grew up in a liberal-minded era that heralded the birth of a modern Europe. Thanks to the invention of the engraving, an art form that Dürer himself often employed with great mastery, the artistic concepts of northern Europe became known in the south, and vice versa. This brought about the fusion of the Gothic and the Renaissance styles, the latter just beginning to appear in Italy. Dürer lived in a profoundly humanistic and spiritual age. Dürer believed, as did his contemporaries, that the human senses, especially sight, should be the artist's guide, and everything he perceived and felt, everything in nature, was a sign of something beyond human experience.

Dürer's definition of painting was "to depict any visible object on a flat surface," but it was also a high art form, for sight was, in his opinion, "the noblest of man's senses."

Albrecht Dürer painted many dozens of watercolors of varying types—some in monochrome, others absolutely pure, using a whole range of colors. In all of them, you can see his sensitivity to color, his attention to detail, and an extraordinary talent for capturing the atmosphere of his subject. In true Renaissance style, he traveled widely, taking enormous interest in all he saw and could learn. When he was in Venice, he captured in his watercolor notes the atmosphere and the light of the mountains he had crossed in his journey; and thereafter, even on his return to his native Germany, this way of making the feeling of atmosphere and light a part of his painting was a permanent addition to the way he captured detail.

Dürer also gained a mastery of the brush that is still admired by many today.

He was also a forerunner in using watercolor to paint detailed studies of animals and plants, as well as views and drafts for oil paintings—tasks that topographers and romantic artists would soon be carrying out in watercolor. Dürer was also a pioneer of a style that became popular much later in history: the use of "local color." He once said that a watercolor should not be shaded in black but in color, so that the color of the object would not lose its identity. It is for all these reasons that Dürer was, without doubt, a precursor of the English watercolor movement, for he was the first European artist to work with watercolor for its own sake, and not only to illustrate a text or to make a draft of a picture, which was what painters would do for centuries after his death. There were a few isolated exceptions, such as Van Dyck, who was the link between Dürer and the English painters of the 18th century, whom we will discuss later.

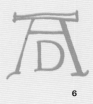

6

Fig. 4. (Previous double page): Joseph Mallord William Turner, *San Giorgio Maggiore Seen from the Customs-post.* Tate Gallery, London.

Figs. 5 and 6. Albrecht Dürer, detail of *Self-portrait with Gloves.* Prado Museum, Madrid. Below: the anagram with which Dürer signed his engravings, drawings, and paintings.

7

8

Figs. 7 and 8. Albrecht Dürer, *View of Kalchreuth* and *View of the Arco Valley*. Kunsthalle, Bremen, and Louvre, Paris. Dürer was a precursor in the evolution of the watercolor. He created a total of 188 paintings including many watercolors. Here are examples of the style in which he painted landscapes.

Van Dyck, Lorrain, Poussin

During the 17th century, a number of artists used watercolor to paint studies, usually in just one tone. One of these artists was Peter Paul Rubens, who also painted several English landscapes with this technique. However, it was one of his students, Anthony Van Dyck (1599-1641), a magnificent painter of portraits in oil who, following his master to England in 1632, depicted the English countryside in watercolor, rediscovering the technique in all its purity, with all its fluid, transparent colors on white paper. It was at this time that the landscape became a new artistic category in its own right in northern Europe, as seen in the works of Dürer, Van Dyck, and the Dutch School in general. During this era intensive contact between northern and southern Europe developed, and artists in Italy and France also began to paint landscapes—some included figures and were perhaps less "pure," but they were still landscapes. Claude Lorrain (1600-1682) and Nicolas Poussin (1594-1665) created a new, southern style of landscape painting. This was based on "chiaroscuro," the handling of light and dark in a painting. Lorrain and Poussin, both French but active in Italy, created grand and noble landscapes charged with spirituality and "ideal" beauty—the product of a combination of the northern-style, baroque chiaroscuro landscape and the southern tradition of the symbolism of the human figure.

In painting these landscapes, Lorrain and Poussin would first make small drafts, often from real life, painting in gouache with just one or two colors but containing a surprising variety of hues.

Fig. 9. Anthony Van Dyck, *A Country Path*. British Museum, London. A hundred years after Dürer, Van Dyck, famous for his oil paintings, surprised people with a number of his watercolors.

Figs. 10 and 11. Top: Claude Lorrain, *Landscape with a River. View of the Tiber from Mount Mario*. British Museum, London. Below: Nicolas Poussin, *The Moller Bridge Near Rome*. Graphische Sammlung Albertina. Vienna. In the 18th century, Lorrain and Poussin cultivated the grandiloquent landscape through gouache sketches.

9

10

11

Gainsborough, Sandby, Cotman, Cox

After a period of monochrome, valuist painting, color triumphed in the 18th century. But why did the renaissance of watercolor occur precisely in England at the beginning of the Industrial Revolution?

Well, at this time a prosperous middle class, which greatly admired foreign, European culture, was springing up in England. The members of this new middle class began to tour Europe, visiting its museums and buying souvenirs and paintings there. This was the "Grand Tour," the long voyage that all Englishmen of any culture "had to" undertake. And it is on the Grand Tour that the love and memory of landscape was born—a landscape painting or engraving bought from an artist. The figure of the "topographer" was also born in this way, the artist who depicts a real landscape, but adding aesthetic elements to make the painting more "picturesque." Later, the English transferred the concept of the picturesque to their own country, and what they called "the romantic landscape of Scotland, Wales, or the Lake District" became a suitable subject for painting. Great artists such as Thomas Gainsborough, Cox, Cotman, and Alexander Cozens began to depict these "suggestive picturesque landscapes" in both oil and watercolor, yes, watercolor.

But perhaps they would not have painted in watercolor if it had not been for Paul Sandby (1725-1809). This artist and topographer, who engraved and drew hundreds of landscapes and views of Windsor Castle, began to color his en-

Fig. 12. Thomas Gainsborough, *Horse and Cart Crossing a Clearing.* British Museum, London. Although Gainsborough made a name for himself originally as a portrait painter, to the point of becoming the favorite painter of the English royal family, he always painted landscapes too, a subject for which he felt a true vocation.

12

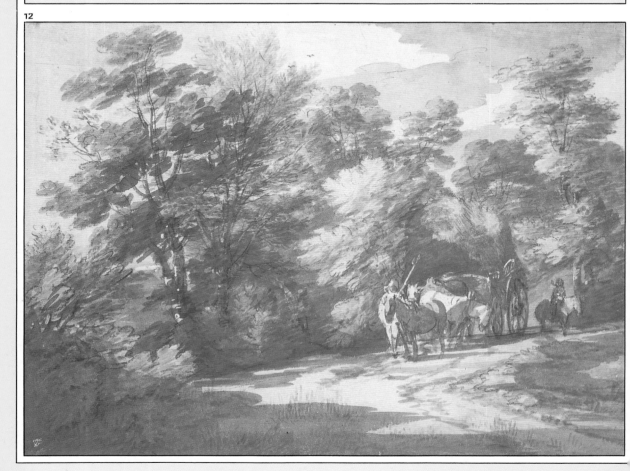

graved plates, and the medium he chose to do this with was precisely watercolor.

Sandby was most meticulous, working on a range of colors layer by layer, slowly building up color as each layer dried. Some of his contemporaries may have exaggerated their praise of his work, but they could see that Paul Sandby was taking the history of watercolor a step forward, elevating it to the status of an ''independent art form,'' making it the equal of oil.

13

Fig. 13. Paul Sandby, *Old Tree by the Beach*. Victoria and Albert Museum, London. Paul Sandby was a key figure in the evolution of the watercolor in England, as is amply demonstrated by the fact that the English call Sandby ''the father the watercolor.''

14

15

Figs. 14 and 15. John Sell Cotman, *Pond in a Park*. British Museum, London. David Cox, *Canal in North Wales*. Victoria and Albert Museum, London. Cotman, like Cox, belonged to the golden age of the English watercolor; works by both artists were included in the first exhibition of watercolors held in London in 1805.

Thomas Girtin (1775-1802) bridged the gap between the "topographic" and the "romantic." He rediscovered the use of local color—shading with color rather than with grays. He observed nature and captured it in great detail; he observed and felt atmosphere and caught it on paper. Girtin met Turner (1775-1851) at the studio of Dr. Monro, an enthusiast and collector of watercolors. Girtin died young, at the age of just twenty-seven. At this time, Turner's attention was on "invention," or "imposing his own ideas and feelings on the reality of the subject." Through his great ability, Turner was a member of the Royal Academy very early in his career, despite the fact that some critics of the time said of his works that "they are pictures of nothing and things like that." Turner was an oil painter—not for nothing was he a member of the Royal Academy—but he also turned constantly to watercolor, systematically experimenting with the expressive qualities of color and light, as a medium both realist and visionary, atmospheric and suggestive. The artist used all the available techniques: wash, rubbing, scratching, gouache, and retouching in gouache. He made colors vibrate and captured distance and light in all parts of his paintings. Being a restless character, Turner was a tireless traveler, something of a wastrel—though not a generous person, according to his contemporaries—and he knew Italy, Switzerland, France, and Germany as well as he knew England.

16

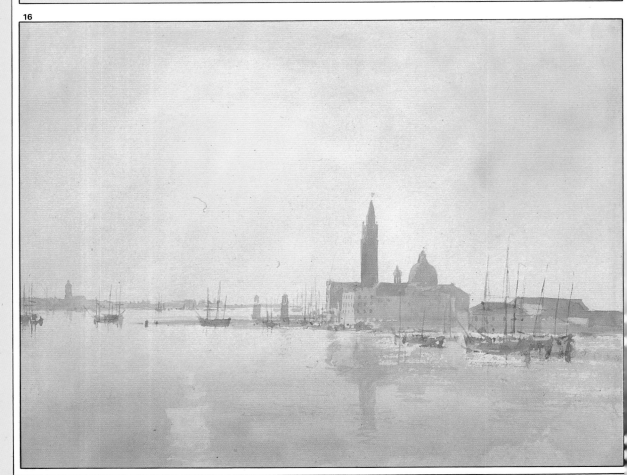

Figs. 16 (also pp. 8-9) and 17. Joseph Mallord William Turner, *San Giorgio Maggiore Seen from the Customs-post*. Tate Gallery, London. *The Biastiaz, near Martigny* (fig. 17). Tate Gallery, London. Turner was without doubt England's greatest watercolorist. With his vision of light and color, he was a precursor of the impressionists.

Fig. 18. Thomas Girtin, *Kirkstall Abbey*. Victoria and Albert Museum, London. A companion of Turner at Dr. Monro's studio, Girtin was a great influence on Turner, who imitated his style and use of color in his earlier works. Girtin died tragically young, at the age of twenty-seven.

17

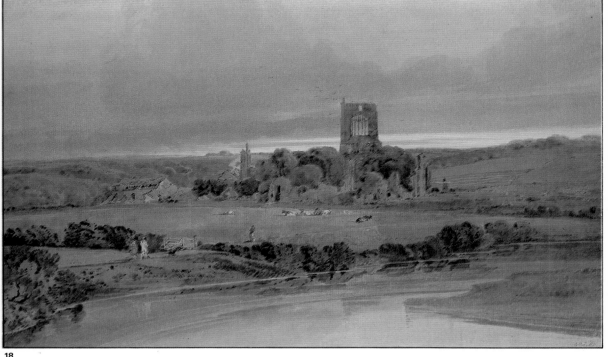

18

Constable, Bonington, Peter de Win

Another great English master was painting at the same time as Turner. This artist was John Constable (1776-1837), whose work, however, took a very different direction, as he set himself the difficult artistic, moral, and vital goal of "painting naturally." For Constable, this meant that his subject contained all beauty in itself, and this was what he had to portray, not a phantasmagoric or fantastic vision of reality which he called in his letters a "fashion" —the fashion of "bravura," as it was known in Britain at that time— and that only the true, the natural, could hope to pass on to posterity.

This does not mean that Constable was a reactionary or an "imitator of the classics." On the contrary, Constable stayed in his homeland and studied landscapes, drawing and painting them an infinite number of times. An infinite number of skies, clouds—in England, the colored cloud effects are truly remarkable—and landscapes so "natural" that they have nothing in common with classic idealism, but come very close to the modern concept of art as the personal, intimate, humble vision of the painter before nature. Of course, Constable, like Turner, was a member of the Royal Academy.

From all this, it can be gathered that the influence of Constable was perhaps more important on French painting than on English art. The French romantics seized on the spontaneous but realistic work of Constable, whereas the English themselves painted the more picturesque, charming, suggestive landscapes of their country, as you can see in the work of John Sell Cotman and Peter De Wint, who had studied in Dr. Monro's studio with Girtin and Turner.

As you will recall, we are discussing the 18th century. In France, watercolor oc-

Fig. 19. John Constable, *Trees, Sky, and a Red House.* Victoria and Albert Museum, London. Though he painted mainly in oils, becoming one of the most renowned landscape painters of his time, Constable also occasionally painted in watercolor, developing a highly personal style, as you can see in this example.

19

cupied the lowly role of being used to make drafts or decorations. However, Normandy, with its great natural beauty and its medieval architecture, was attracting many English artists desirous of painting grandiose, beautiful, picturesque landscapes.

Among these artists was Richard Parkes Bonington (1802-1828), who published his watercolors in a travel book on France. In fact, he stayed on in France, working as a student in Antoine-Jean Gros's studio (which also included Eugène Delacroix among its pupils at that time), learning to paint in oil from the charismatic professor. Delacroix was impressed by Bonington's talent. Bonington urged Delacroix and other French artists to paint in watercolor, showing them his own works, even exhibiting some of them in Paris. Bonington's work reveals his mastery in the technique of watercolor: a very pure execution, fluid brushstrokes, and great refinement in chromatic harmony.

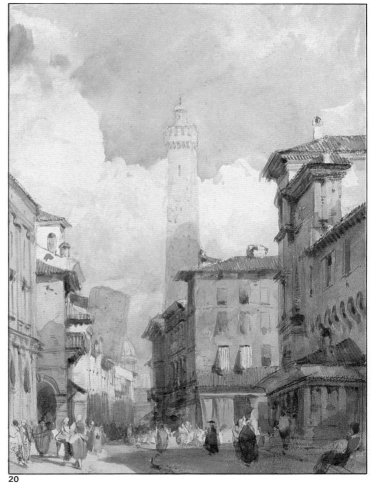

20

21

Fig. 20. Richard Parkes Bonington, *Bologna: The Leaning Towers*. Wallace Collection, London. Bonington introduced watercolor into France through a circle of French artists that included Gros and Delacroix, creating the ''Bonington style,'' influential even after his death at the age of twenty-seven.

Fig. 21. Peter De Wint, *The Thames at Windson*. Royal Watercolor Society, London. De Wint studied at Dr. Monro's studio in London, where he met Girtin, who influenced his technique and use of color. De Wint was an excellent landscape painter, with a special ability to portray atmosphere.

Delacroix, Fortuny, Harpignies, Palmer

Figs. 22 to 25. This page, top: Henri Harpignies, *View of the Seine and the Tuileries*. Louvre, Paris. Below: Eugène Delacroix, *View of the English Countryside*. Louvre, Paris. Following page: Marià Fortuny, *Landscape*. Prado Museum, Madrid. Samuel Palmer, *Calm Shadows*. Royal Watercolor Society, London. Four. magnificent watercolors demonstrating the quality and variety of styles that existed in the 19th century in France, Spain, and England.

22

23

In 1825, Delacroix visited England for the first time, meeting up again with Bonington, who showed Delacroix some sketches he did of Moroccan girls. These sketches immediately fired Delacroix's lively imagination, and in 1832 he traveled to Morocco, where he filled pad after pad with watercolor sketches. The French artists of the following generation, such as Henri Harpignies (1819-1916), were influenced by Delacroix's technical excellence, but not by his "romanticism." Meanwhile, what was happening in Spain, that country of great painters? In Spain, watercolor was not well known yet, and would not be until the end of the 19th century when a Catalan artist, Marià Fortuny (1838-1874), popularized it not only in Spain, but also in Italy and France.

Fortuny used watercolors with all their resources, from the layer-by-layer addition of meticulous detail to a pre-impressionistic synthesis of stains. Meanwhile, in England, Samuel Palmer and other artists used religion and alchemy to transform reality, producing visionary, symbolic, spiritual illustrations.

25

24

The impressionists

Perhaps the most important aspect of impressionism was the abandonment of the studio to paint "en plein air," producing definitive works from life. Claude Monet, for example, decided to have his studio on board a boat, becoming a part of the landscape itself, painting as he wished. The impressionist painter James Whistler, though born in the United States, made his home in Europe.

The impressionist period was graced with three artists of exceptional genius. These artists were Paul Cézanne (1839-1906), Paul Gauguin (1848-1903), and Vincent van Gogh (1853-1890).

An idea of Van Gogh's importance is expressed in this quotation from another impressionist, Camille Pissarro: "I knew that, sooner or later, he would either go mad or be greater than all of us. But I never imagined that he would do both."

Gauguin, despite the stormy friendship that united them, differed from Van Gogh in his arrogance, his confidence in his power as an artist—which he undeniably possessed. He traveled to the South Seas, where he lived until his death with the natives he grew to love so much. There, he painted intense, brilliantly colored watercolors of immense expressive power.

Cézanne began his painting in the company of the impressionists, but soon decided that he wanted to paint alone, surrounded by nature, to achieve an art that would be lasting—"less superficial than impressionism," something "like the art we see in the museums," as he once said. At least six hundred watercolors by Cézanne are still in existence, though some others have been lost. He painted these watercolors the same time he was painting in oils, so that

Figs. 26 to 30. Some examples of watercolor landscapes painted by members of the impressionist movement. Below: Cézanne, *Provence Countryside*. Kunsthaus, Zurich. Following page, from top to bottom: Paul Cézanne, *Mont Saint-Victoire*. Louvre, Paris. James Whistler, *Port of Venice*. Freer Gallery of Art, Smithsonian Institution. Vincent van Gogh, *Outskirts of Paris, the Industrial Zone*. Stedelijk Museum, Amsterdam. Paul Gauguin, *Landscape of Tahiti*. Louvre, Paris.

26

you can see in them a reflection of his entire development as a painter—from his romanticism to his most creative period, and reaching, at the end of his life, a liberation of exultant lyricism. The later watercolors are composed of transparent stains layered by small planes or "facets" that build up the object; they are unified by the expanses of the white paper, which generate and represent light. This was the beginning of pure watercolor.

27

28

29

30

Painters influenced by Homer and Sargent

In North America, between 1870 and 1890, Winslow Homer and John Singer Sargent gave new meaning to watercolor, rejecting meticulous detail in favor of richness of color and direct brushstrokes. Taking the Bahamas as his subject, Homer (1836-1910) produced a series of vigorous watercolors. Sargent (1856-1925) painted fresh, brilliantly colored watercolor pictures of the humblest subjects. Their example was followed by such painters as Childe Hassam and John Marin. Finally, Edward Seago was a British painter who, through strict artistic discipline, depicted color and light with impressive mastery.

31

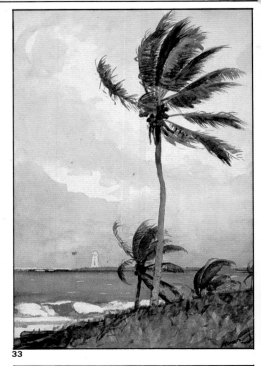

33

32

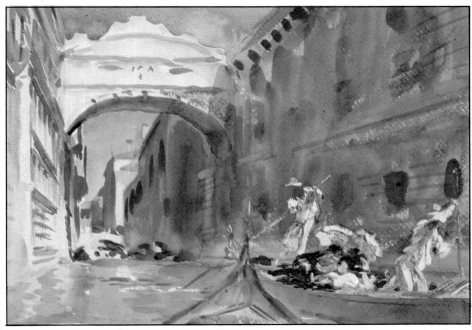

Figs. 31 to 35. Five magnificent watercolors representing one hundred years of watercolor by five famous artists. Fig. 31: Childe Hassam, *The Gorge, Appledore.* Brooklyn Museum, New York. Fig. 32: John Singer Sargent, *The Bridge of Sighs.* Brooklyn Museum, New York. Fig. 33: Winslow Homer, *Palm Tree at Nassau.* Metropolitan Museum of Art, New York. Fig. 34: John Marin, *Lower Manhattan.* The Museum of Modern Art, New York. Fig. 35: Edward Seago, *Norfolk Fields in Winter.* Private collection, New York.

34

35

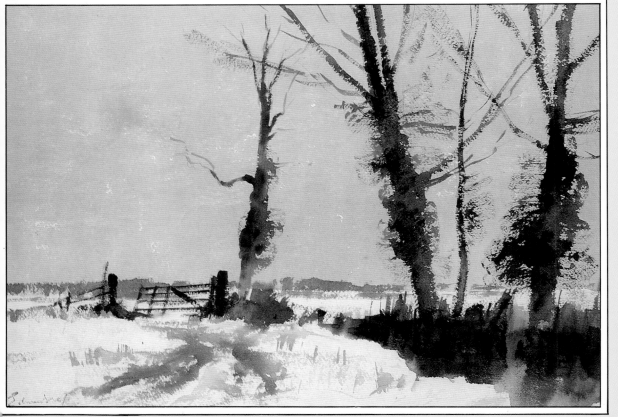

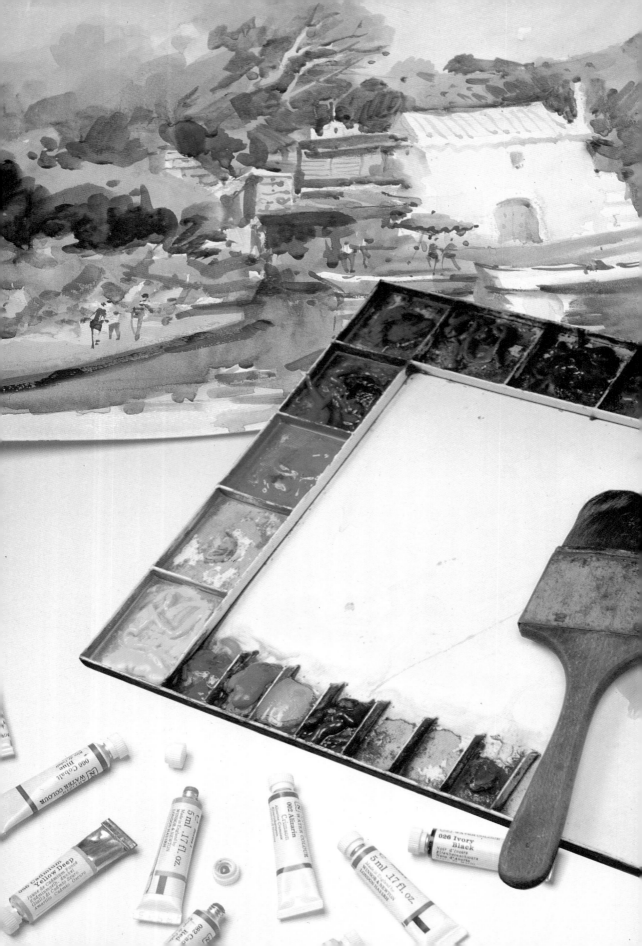

MATERIALS
──USEFUL TO──
THE LANDSCAPE
PAINTER

*T*here are no secrets, no "tricks." The materials for painting in watercolor are always the same, paper, brushes, colors, and water. But each artist has "his things," his style and customs. For instance, Julio does not paint with a paint box, but with a large palette he bought in the United States; and he does not draw with a pencil but with a black or red ballpoint pen, a blue wax crayon, or India ink! He also has his own range of colors, with two favorites, Indian red and viridian. One color he never uses is yellow ochre.

This section deals with Julio Quesada's materials.

Studio equipment

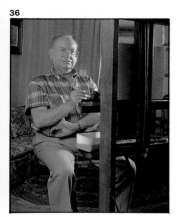

36

Here is Julio Quesada at home in his studio, a cheerful room with light coming in through three windows from a busy street of Madrid. It is not a very large room, maybe about 200 square feet (20 square meters), part of which is taken up by his "store" of folders and paper. This is where Quesada paints most of his portraits; he paints his landscapes in the open air, from real life. Quesada explains that in this seemingly tiny space, he can stand back enough to paint even pictures 78 ¾″ (2 meters) high. He has two wooden studio easels with adjustable height, on which he rests his board and paper. The artist usually paints standing up, though with the years he tires more easily and makes himself sit down to paint. Strangely, he sits on a piano stool. Of course, as we said before, besides being a fine painter, Quesada is also an excellent pianist who even composed music in his youth! He especially loves playing and listening to the music of Debussy.

Next to the easel, there is a very simple and useful piece of furniture: It is

37

38

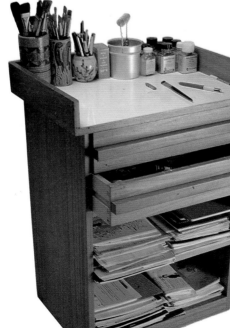

Figs. 36 and 37. Julio Quesada painting in his studio at the easel, which you can see on the right in Fig. 37. On the easel, you can see Quesada's brushes, palette, and plastic water container. Underneath the easel is his stool, the same one he uses when playing the piano.

Fig. 38. This is the cabinet on wheels used by Quesada; it has a Formica top, and drawers and shelves to keep materials, books, notes, documents, etc.

a little cabinet on wheels, which makes it easy to move around, 31 ½″ (80 cm) high by 23 ⅝″ (60 cm) wide and 19 ⅝″ (50 cm) deep, with a white Formica top, and wood covering three sides. There are two drawers and two shelves where Quesada keeps his painting materials; he stores his pots of brushes, pencils, varnish, and medium on the white top, which he also uses as a palette from time to time.

Paper

Figs. 39 and 40. Quesada uses coarse-grain paper for painting portraits in watercolor, and medium grain for landscapes, with a size no larger than about 24 × 19″ (60 × 50 cm).

Figs. 41 to 43. Paper used by Julio Quesada: coarse-grain "Caballo" by Schoeller for portraits and landscapes larger than 24 × 19″ (60 × 50 cm). For smaller pictures, he uses fine- or medium-grain paper made by Fabriano, Arches, Canson, or Whatman.

Julio Quesada is prodigious in his use of paper of different makes and textures. As you know, paper for watercolor painting has to be thick, weighing 140 lbs. (250 or 300 grams), and has to be of good quality, with a certain amount of texture. Depending on the subject he is going to paint and the size of the painting, our artist uses fine-, medium-, or coarse-grain paper. For small watercolors, up to 24 × 18″ (60 × 50 cm), Quesada uses fine or medium grain; and for larger paintings, especially portraits, he uses coarser grained paper. Quesada usually uses paper known here as "Caballo," made by Schoeller, for large paintings. For landscapes and other subjects, he uses any good brand of paper, such as Fabriano, Arches, Canson, or Whatman, either loose sheets or special blocks for watercolor.

Quesada is also careful to always paint on the side where the watermark is most clearly visible, though nowadays this is not so important, as paper is gummed on both sides.

Still, on the subject of the quality of the paper, we quote Quesada: "Some of these coarse-grain blocks have a grayish-yellow tone. I once painted a series on the theme of dusty roads that ran through orchards with palm trees, and this paper was just right for the job!"

Fig. 41. Coarse-grain paper. Fig. 42. Medium-grain paper. Fig. 43. Fine-grain paper.

Materials and tools for drawing

Paper for painting in watercolor has to be secured in some way— this is known as "mounting" the paper. Julio Quesada often uses blocks of paper, especially for painting landscapes. These blocks can be fine- or medium-grain paper of any make, and have the advantage of already being stretched and glued, so that you just have to paint your picture, wait until it is dry, and then, carefully (it could tear), separate your painted sheet from the block. The largest block Quesada uses is one measuring 46 × 62 cm (about 18 × 24″). When Quesada uses a loose sheet, usually when painting in the studio and with larger sizes of paper, he has to stretch it. Quesada explains that, at first, he did this in the way one usually learns how to stretch paper— by wetting it and sticking it down to a board with tape before it dries. When Quesada worked a lot at home, he used to literally soak the paper in the bathtub before trying to fix it to the board. Often, however, he found that he could not fix it, and wasted too much time trying without success to get the thing stuck down. So now he sticks the paper straight onto the board dry, then he wets it with a sponge. This system stretches the paper perfectly and with fewer problems.

The adhesive tape you use can be gummed paper, which becomes sticky when you wet it with a sponge, or any plastic tape or adhesive paper, as long as it is fairly wide.

Fig. 44. Paper for painting watercolors is available in blocks of 20 or 2 sheets of different grains textures, and sizes mounted and stretche on cardboard.

Figs. 45 to 47. Here yo can see the process Julio Quesada follows t mount and stretc watercolor paper.

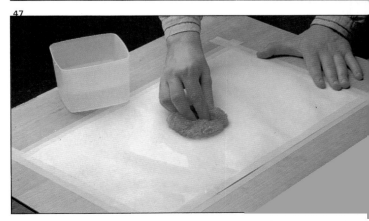

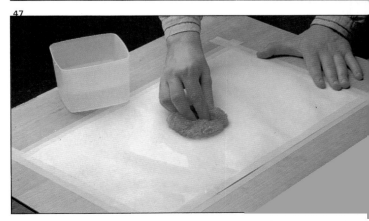

Julio Quesada usually draws on his paper before painting.

He often uses wax crayons, and makes no bones about the fact that he draws. This is rather surprising since the wax lines will reject any watercolor painted over them—wax being resistant to water—so that they will show through in the picture. Quesada explains, "I draw as much as I need, and when I want to bring out the quality of the wax, I press a little harder, so that the watercolor cannot cover it, and the wax is clearly visible at the end. But, if I just rub lightly, the watercolor gets into the chinks of the wax and in the end the two blend together. Since I use various colors, depending on the tonalities of my subject, it does not matter if you see the wax, quite the contrary. I especially use the light blue, because it blends with the cool colors and contrasts with the warm ones— the pink crayon if it suits the subject, or the yellow one if it is a subject with a lot of light."

Quesada also draws with Indian ink, using a "feeder" to load the drawing pen, which he uses as a normal pen. Sometimes, he does not wait for the ink to dry, so that it mixes a little with the watercolor, as you can see in Fig. 49.

Another tool he uses in drawing is a ballpoint pen, not just black but one with four colors, using whichever best suits his subject, usually the red. As you can see, Quesada never rubs out, his first drawing is always the definitive one.

Fig. 48. These are the materials Quesada uses to draw landscapes: (from left to right) fine-tipped marker, ballpoint pen with four colors, wax crayons, and the "feeder," the implement for loading drawing pens and compasses with ink.

Fig. 49. A watercolor by Quesada, drawn using ink and the "feeder."

48

1 2 3 4

5

49

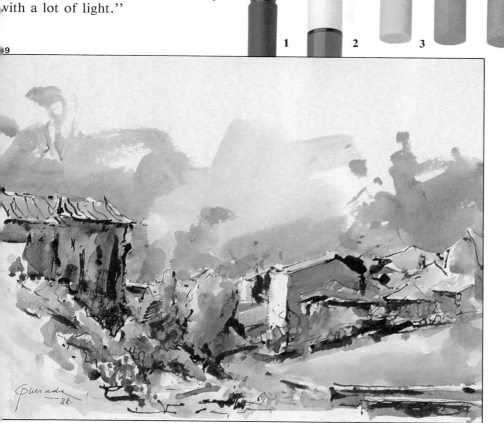

Brushes, palette, watercolors

Watercolor brushes, as you may know, are made of various types of hair. They need to be fine without being weak, and they need to have a certain strength and tension.

The best brushes for watercolor are without doubt those made of sable hair, but they are also expensive. Brushes made from the hair of the stag, the polecat, or the squirrel are less expensive. Perhaps the best quality brush after the sable hair is a type of squirrel hair, mongoose; though the choice of brush, as in everything else, depends on your style of painting. Quesada paints mostly with sable-hair brushes. He uses a maximum of three brushes in any one painting; for example, he might use a no. 8, a 14, and a brush thicker than a no. 20—all thick brushes. He never uses a thin brush since he can get lines, brush-strokes, as fine as he wants using a thick, round brush with a point or a flat brush held sideways. Quesada sums up by saying, "Nobody I know paints with thin brushes."

Besides round-headed brushes, he also uses wide, broad-headed flat brushes, as you can see in the photograph below. These flat brushes are not made of sable hair; they are made of mongoose, or squirrel, hair, which is a good hair that is even denser than sable. As you can see, one of these brushes is really broad, almost 2 ³/₈″ (6 cm). Quesada uses this brush to make broad strokes, especially for painting the sky or to wet his paper, making the different areas more or less wet as he desires.

Fig. 50. The watercolor brushes Julio Quesada uses in his painting. From left to right, (1) 2 ³/₈″ (6 cm) mongoose-hair flat brush; (2) and (3) ³/₄″ (cm) putois (polecat) and sable-hair flat brushes and (4), (5), (6) sable-hair round brushes nos. 14, 8, and 3.

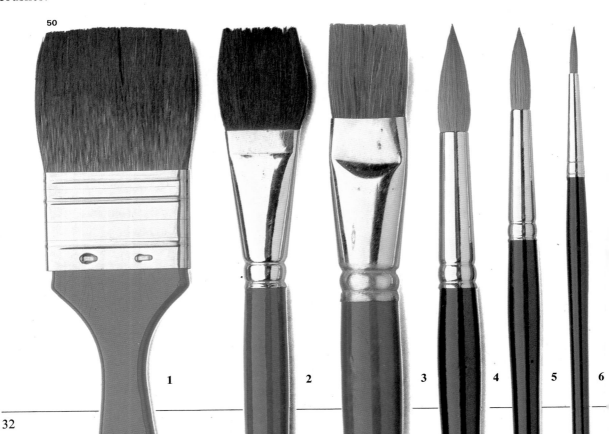

50

1 2 3 4 5 6

lio Quesada always paints with good-
ality colors. He admits that he is
finicky" about clean colors. Because
 is concerned about what may happen
 the future, he never uses poor-quality
ints since the colors may change with
me. He usually uses tubes of creamy
atercolor, squeezing it out onto the
lette so that, even if it dries, it can be
ed again. Watercolors in pans he uses
ly for painting small sketches. Obvi-
sly, if he paints with tubes of paint,
 needs a palette. You can see the type
 palette Quesada uses in Fig. 51: A
rge palette with lots of space and com-
rtments for paints along three sides.
is palette is made of hard plastic,
ough there are palettes made of ena-
eled metal—specially made for water-
lor. Quesada likes this one particularly
cause it has a big top, so that he can
so protect his colors and make sure
thing gets stained.
e artist always keeps his paints in the
me order, so he cand find them almost
thout looking. In Fig. 52, you can see

the colors he uses and the order he puts
them in.

Quesada points out some interesting
things; for instance, he does not use
Prussian blue, but phthalo blue, which
has the same tone but is more perma-
nent. Also, he thinks some colors are not
suitable for painting in watercolor, as
they are too dominant and make mix-
tures dirty. He totally disdains ochre,
and does not like orange or vermilion
either.

Fig. 51. Quesada's plas-
tic palette, with lid, pans
of color, and central
space for mixing paint.

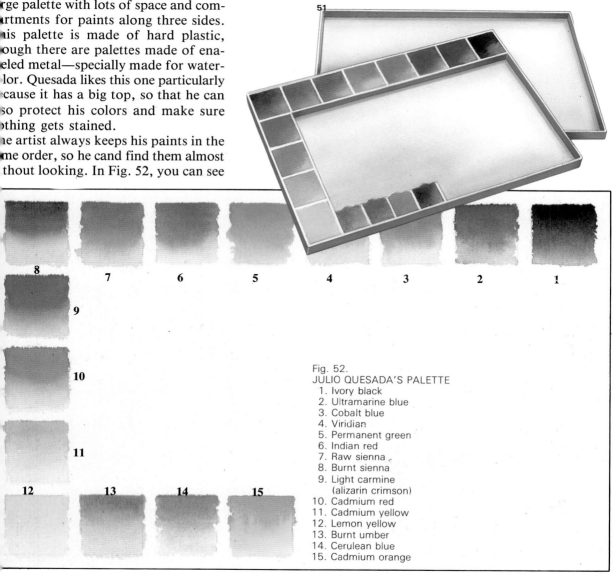

Fig. 52.
JULIO QUESADA'S PALETTE
1. Ivory black
2. Ultramarine blue
3. Cobalt blue
4. Viridian
5. Permanent green
6. Indian red
7. Raw sienna
8. Burnt sienna
9. Light carmine
(alizarin crimson)
10. Cadmium red
11. Cadmium yellow
12. Lemon yellow
13. Burnt umber
14. Cerulean blue
15. Cadmium orange

Equipment for painting outdoor

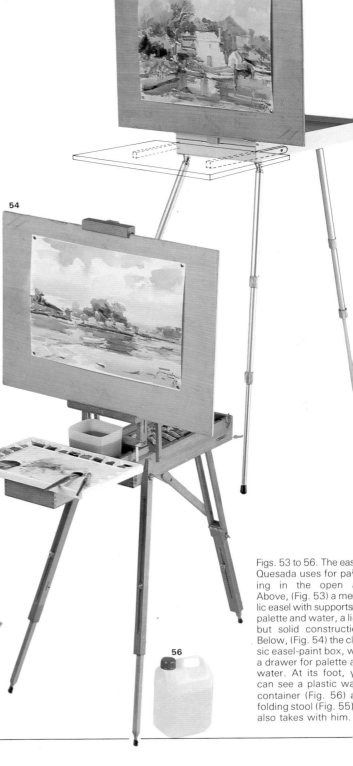

Now we will discuss the equipment that Quesada takes with him when painting in the open air, starting with clothes. In this respect, Quesada says a cap with a visor is "absolutely necessary to protect you from the sun, especially when painting against the light."

Of course, he takes an easel. He used to have one that folded, and carried a paint box separately, but for years now, he has been using an easel that has a tray incorporated into it that holds his paints and brushes. Quesada has two of these easels, one made of wood, like an oil painter's but narrower and lighter, with a tray for the palette; the other one is very modern and functional —designed specially for painting in watercolor— made of white enameled metal. It is light and very easy to carry and set up, with extendable arms to hold the palette. The two easels are shown in Figs. 53 and 54. In the open air, Quesada paints sitting down, adjusting the easel to the right height, with the paper completely vertical, never at an angle. As we said before, he usually paints with blocks of paper, but when he is going to do a large picture, he takes a board to mount the paper on.

Water is another important item. Quesada always takes a large plastic container with him, from which he pours out water to paint with into a smaller plastic container, changing it when it becomes dirty.

Figs. 53 to 56. The eas Quesada uses for pa ing in the open Above, (Fig. 53) a me lic easel with supports palette and water, a li but solid constructi Below, (Fig. 54) the c sic easel-paint box, w a drawer for palette water. At its foot, can see a plastic wa container (Fig. 56) folding stool (Fig. 55 also takes with him.

When Quesada goes out anywhere, he always takes with him at least one of the two small paint boxes he owns. These two cases, which you can see in the photographs on this page, are made by Winsor & Newton, and specially designed for painting small sketches. They fit into a pocket or into the palm of your hand.

The two cases contain basically the same materials, twelve pans of watercolors and a small folding palette. In one, there is also a small water container. If your paint box doesn't have one, remember to take a small water container with you, as well as at least one paintbrush. These cases are very useful when you want to make quick sketches, as they are easy to set up, are not heavy or troublesome to carry, and contain everything you need. Of course, you have to take a folder of paper with you (the folder can be used to support the paper), or a block of watercolor paper.

Figs. 57 to 60. The small paint boxes Quesada uses for notes, each shown with case, palette, brush, and water container.

Fig. 61. A superb sketch-note by Julio Quesada.

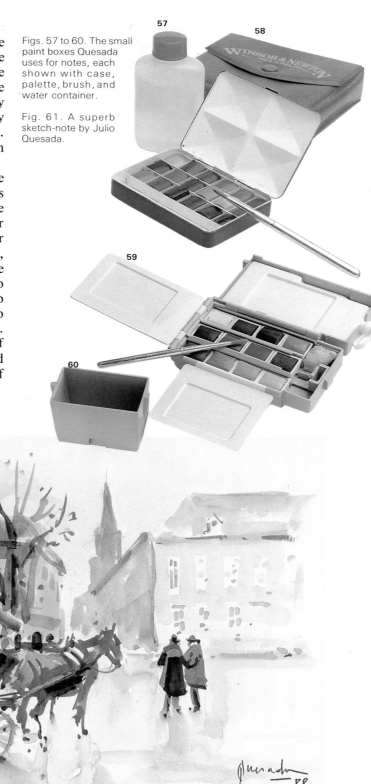

Painting quick notes

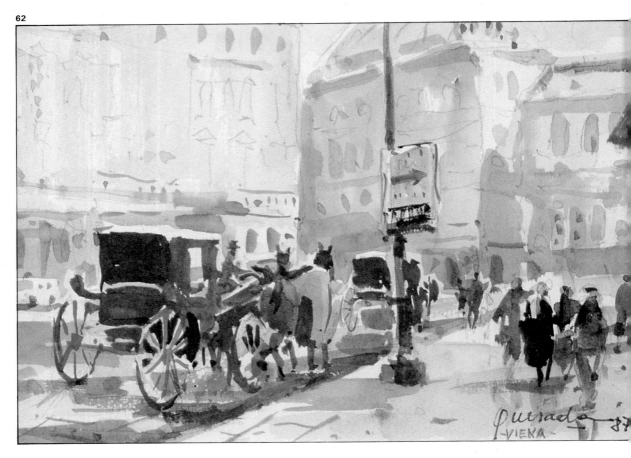

62

Figs. 62 to 66. These illustrations show the artistic quality of the watercolor sketches or notes by Quesada, as well as the paint box he used to produce them.

63

Julio Quesada paints delightful, fresh notes at any time and in any place. There is an anecdote attached to the sketch with the horses (Fig. 62). Quesada says he was walking around Vienna with his wife and a couple of friends when he fell a little behind, having decided to take a few moments to paint a quick note. He asked his companions to wait for him while he did his sketch—the figures on the right of the picture are his friends. The idea, then, is to capture one particular moment, to capture the essence of the subject.

While it is true, as Quesada says, that he never paints sketches, it is also true that he is capable of painting the same subject from the same position three, four, even ten times! So, really, the first picture serves as a sketch, in that it allows him to study his subject carefully. Thus in his later paintings he is able to synthesize and reduce the subject until he captures the essence of it. At times Quesada will paint a note using any paper he has at hand, even if it is not specifically for watercolor. The lovely note at the bottom of page 37 was painted on glossy paper. The type of paper that, in theory, is no good for watercolor. Well, take a look at it! Quesada did it! I believe he surprised even himself with the excellence he produced. The moral is, do not be afraid to try out different types of paper—it will not always work, but you might just get some surprising results.

4

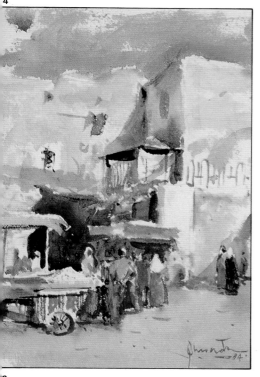

65

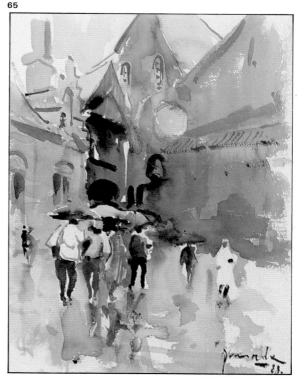

6

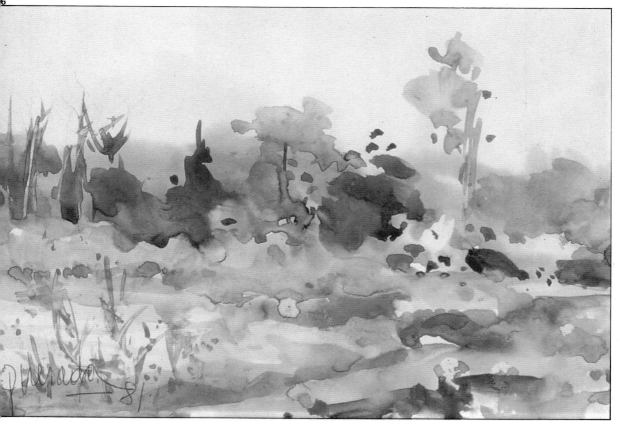

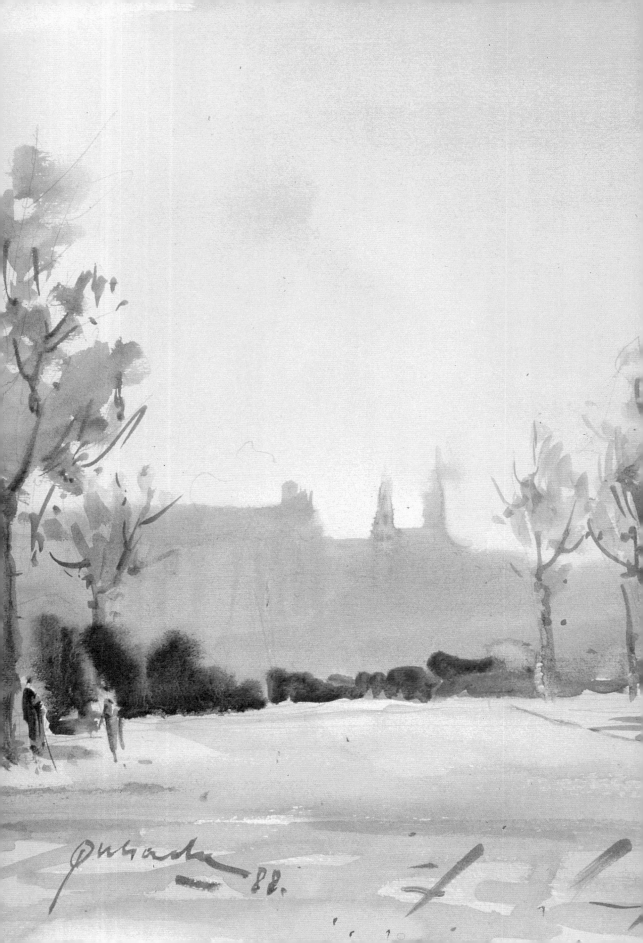

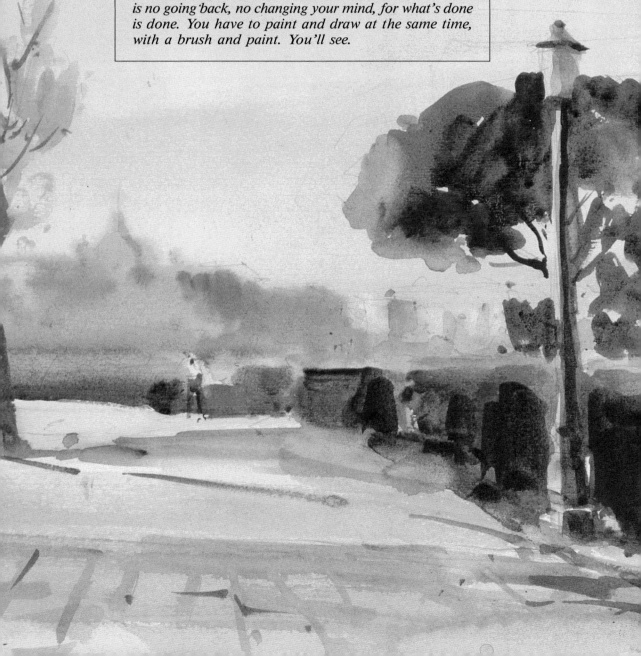

DRAWING, —THE BASIS— OF PAINTING

*T*o draw is to measure, to proportion, to structure and model, and to depict the third dimension—depth, perspective. When you paint with oils, acrylics, or pastels, the initial drawing is important, but you can always draw or paint over what you have already done, correcting your work. But not with watercolor. With watercolor, there is no going back, no changing your mind, for what's done is done. You have to paint and draw at the same time, with a brush and paint. You'll see.

Dimension and proportion

I have nad the good fortune of being present as Julio Quesada draws a watercolor several times. Here is what he usually does, from the first to the last stroke:

With his model and a blank piece of paper in front of him, and a wax crayon or a ballpoint pen in his hand, Quesada spends a good deal of time, at least five minutes, looking at his subject with careful attention —looking from side to side, up and down, then moving his head to look at the blank paper, then back to the model, and back again to the paper. After this, still looking back and forth at the subject and the paper, he begins mentally calculating the dimensions and

68

67

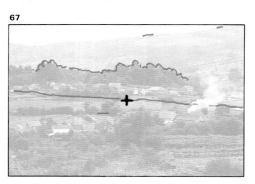

proportions. Though he still does not draw, he is already placing and imagining lines, strokes, and forms.

"That house is a bit above the center, that horizontal line under the house just about divides the picture into two... up above, the outline of the trees is a quarter of the way from the top of the picture..."

Now, Quesada begins to draw, slowly but surely, sometimes not lifting the crayon from the paper, in a continuous line—the horizontal line of the center, the outline of the trees at the top. Suddenly he lifts the crayon from the paper, looks at the subject, jumps to another part of the picture to draw in an almost imperceptible sign, jumps to another part, marking another sign.... These are signs for measurements, dimensions, and proportions that will help him develop his drawing.

69

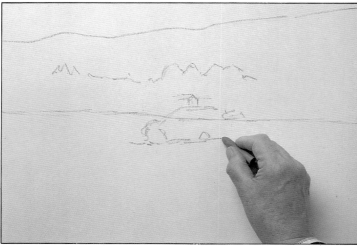

70

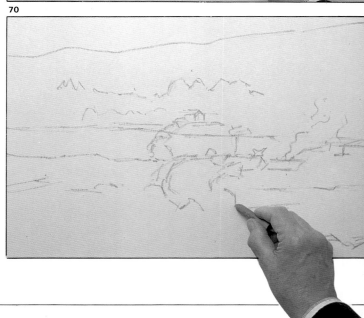

72

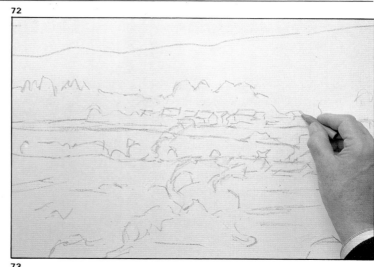

There is a way of drawing everything at the same time, to "see the whole and not just details," as Quesada explains.

"As you know," he continues, "when you're drawing and working out proportions, there comes a moment when you've got your model's measurements, and the distances just come instinctively."

It is like a communion between mental calculation and the space of the picture, a union of the hand and the mind. And it is from this moment on that the artist draws and outlines, looking at the subject, looking at the drawing, looking at the subject... no longer worrying, finishing the drawing with ease.

73

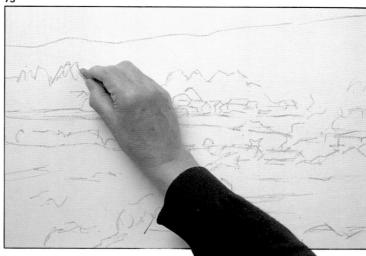

71

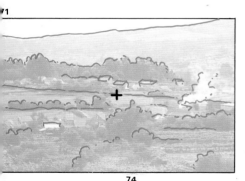

74

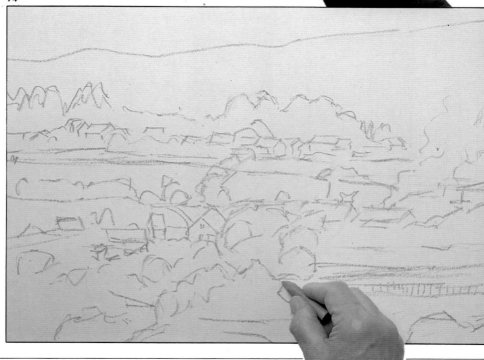

Figs. 67 to 74. Julio Quesada resolves the structure and drawing of his watercolor with speed and assurance, neither rubbing out nor correcting. He begins and ends his drawing with a continuous line, hardly lifting his crayon or ballpoint pen from the paper, but pausing from time to time to calculate and adjust proportions and dimensions.

The fundamentals of perspective

Still on the subject of drawing, let us remind you that with watercolor, the drawing always has to be linear, drawn in pencil, ballpoint pen, crayon, or India ink. There should never be any shading; this will be done later by painting with more or less dark tones and colors. This does not mean that when painting from a linear drawing, the artist cannot incorporate the color black, even the black of India ink, into the shaded areas. For an example, see Fig. 49 on page 31.

But now let's return to our discussion of perspective.

75

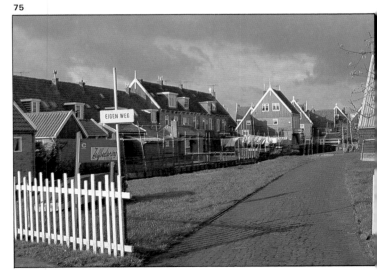

76

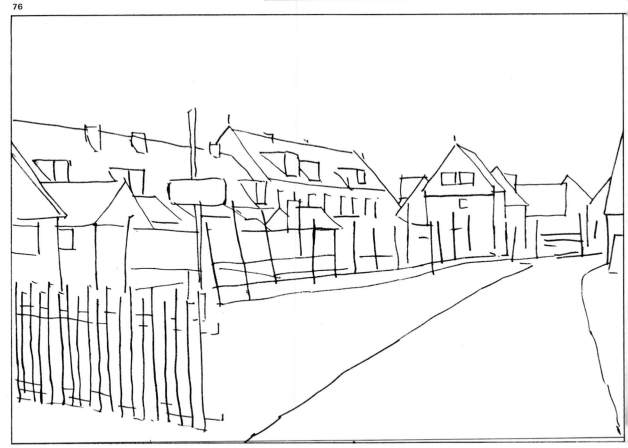

Figs. 75 and 76. Obviously, the preliminary drawing for a watercolor must be linear, unshaded, as watercolor will be used to paint the shadows.

Figs. 77 to 81. Opposite page: Here is a summary of the basics of perspective in diagram form to illustrate the text on the same page.

First, you should remember these two basic factors:

The horizon line (HL)

Vanishing points (VP)

The horizon line is exactly in front of you, at eye level (see Fig. 77). If you happen to be looking at the sea from a high elevation, the horizon line rises with you and you'll see objects from a bird's-eye view (Fig. 78). Thus, when you stoop down, the horizon line also descends, and you will see things from a worm's-eye view (Fig. 79).

The vanishing points on the horizon join the parallel lines perpendicular to the horizon and the lines running obliquely to the horizon. From this, you can deduce that there are two types of perspective:

A perspective parallel to one vanishing point.

A perspective oblique to two vanishing points.

You can see how these basic rules are illustrated in Figs. 80 and 81, and learn how to divide a space in perspective (A) by finding its center. You can also learn how to divide a number of spaces in perspective (B), remembering that first you have to divide the height of the space by drawing in line "a," then roughly calculating the depth of the nearest space "b," and, finally, drawing the diagonal line "c" to find point "d," and so on.

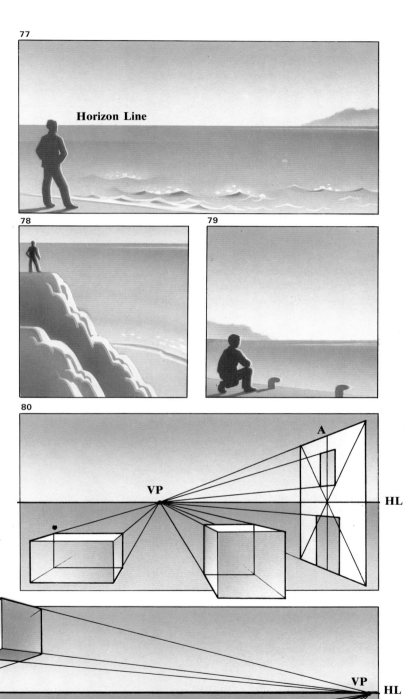

Perspective is necessary

Yes, perspective is necessary. For instance in a country landscape, there may be a house, a row of trees, a fence, a wall, and so on, that have to be put into the picture, taking into account the position of the horizon and one or more vanishing points. To paint an uban landscape, knowledge of perspective is indispensable. On this page, in Figs. 83 and 84, you can see two examples of images that have to be resolved using perspective. They are two views of a place near Amsterdam, Holland. Fig. 83 is basically an example of parallel perspective, formed by the walkway, the fence, and the houses on the right, which converge toward a vanishing point on the horizon. There is also a house in the background which is in oblique perspective. In Fig. 84, you see that the house on the right is parallel to the horizon. The house in the middle, also in parallel perspective, offers a different vanishing point, and the house on the left is in an oblique position to two vanishing points which, as shown in Fig. 85, are outside of the picture.

Finally, observe on the next page two classic examples of parallel perspective from just one vanishing point. They are two brilliant watercolors by Julio Quesada, and show how an artist needs to master perspective in order to put windows, overhangs, pavements, and the high points of buildings in their right place and position. Note, also, that the figures in both pictures are placed rather high up from the foreground, but that the heads of all the figures are in correct perspective to the horizon line—which is, as you will remember, at eye level.

82

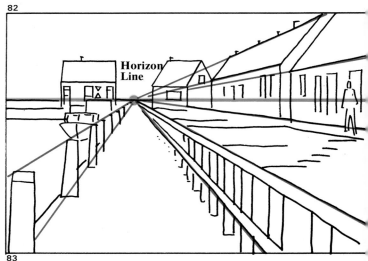

83

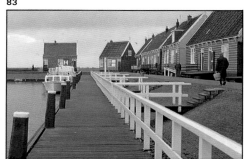

Figs. 82 to 85. Here are two examples of perspective: one is a parallel perspective with just one vanishing point (Figs. 82 and 83), and the other is an oblique perspective with two vanishing points (Figs. 84 and 85).

84

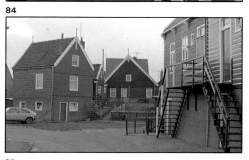

85

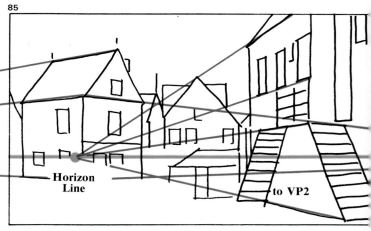

6

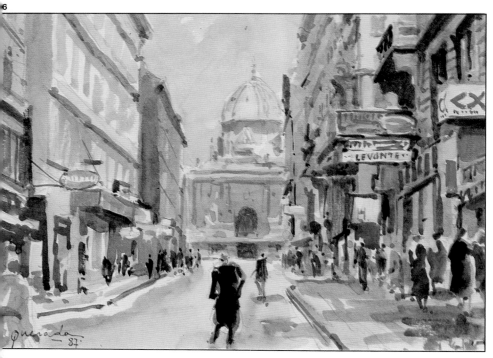

Figs. 86 and 87. Two urban landscapes by Julio Quesada that illustrate the necessity of understanding and mastering perspective.

7

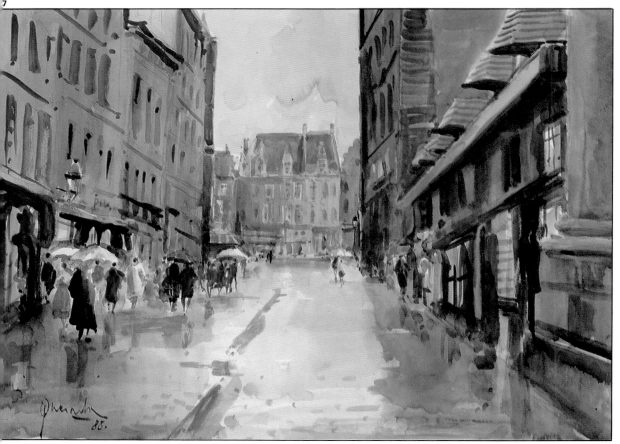

The leading gri

Here is a simple trick to check the perspective of an image when, as very often happens, the vanishing points are beyond the edges of the paper you are drawing on. This is especially helpful when you are working outdoors, with no more support than a drawing block, a board, or a folder.

The solution is easy. Let's suppose that you have calculated the dimensions and proportions, decided the framing, and roughly structured the drawing of the subject you are going to paint. Now, you only need to adjust the perspective of the converging lines and forms. (We should point out here that an expert artist only needs to have the structure roughly drawn to be able to solve the problem of perspective, but let us continue). The solution consists of drawing vanishing-point lines at the top and bottom of the subject (A and B), and then drawing a vertical line at the nearest point to you, to the top of the picture (C). Next, you need to draw a second vertical line going out of the picture (D). Now divide the two vertical lines into identical spaces, in this case into seven spaces (Fig. 90). Then, all you have to do is join the divisions of the two vertical lines. These guidelines will help you get the angles of the lines and forms of your subject (Fig. 90) into a remarkably true perspective.

The above example shows you how to establish guidelines for an image in parallel perspective. For an oblique perspective, the formula is the same, except that you have to work, as it were, double. You draw the vanishing-point lines at the top (A) and bottom (B) of the subject from both sides of the nearest (C) high point. Then, you divide this vertex into a given number of spaces and draw two vertical lines outside of the picture (D, E), one on each side, which you also divide into equal spaces.

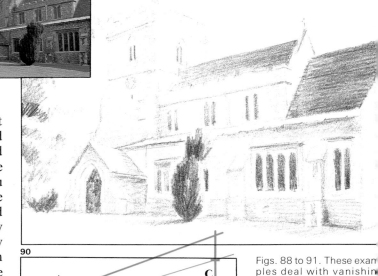

88

89

90

91

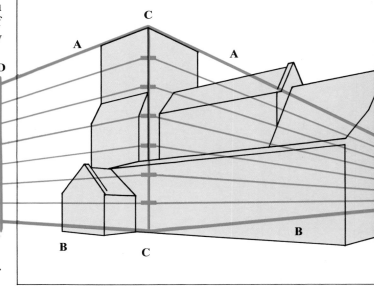

Figs. 88 to 91. These exam ples deal with vanishin points that are beyond th borders of the paper. This usually the case when yo work outdoors to draw buil ings, streets, and so fort When you do not have a t ble or a large, stable suppo with you to trace lines to th vanishing points, the solutio is to draw a guideline, as these illustrations. You ca create good perspective your drawing with the help a guideline.

Atmospheric perspective

92

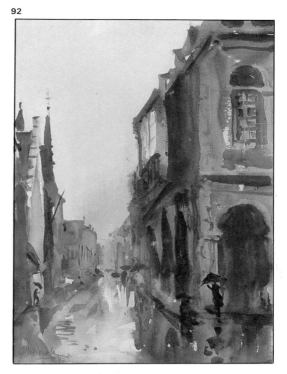

There is also a type of perspective that has neither lines, nor horizons, nor vanishing points, but that also creates the illusion of depth.

I am referring to atmospheric perspective, which is achieved through contrasting and defining the foreground while weakening and fading the color of points in the background. As objects recede into the background, they are generally grayer, bluer, and less defined.

This is something to bear in mind when you want to create a feeling of depth in your work.

The two watercolors by Julio Quesada reproduced on this page in Figs. 92 and 93 are good examples of atmospheric perspective. Note the greater contrast and definition of the foreground in relation to the grayer, less clear background.

Figs. 92 and 93. Atmospheric perspective is almost always a factor in watercolor paintings. There is always a foreground that contains a strong contrast of form and color. And, there is always a fading and blending of color in the background, which becomes more and more accentuated as objects and subjects recede further away from the foreground—houses, trees, or mountains in a distant background are usually painted gray or blue-gray.

93

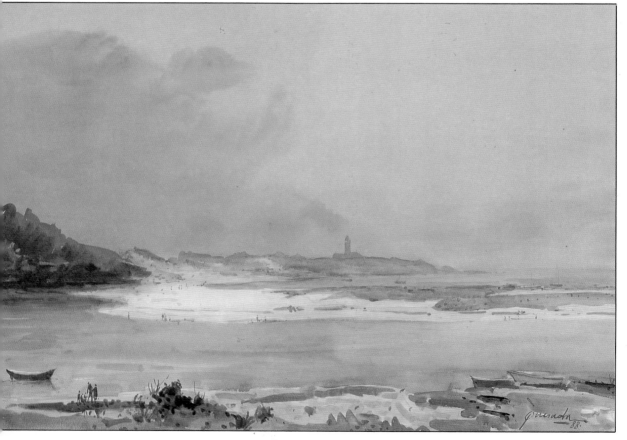

COLOR THEORY
—AND—
PRACTICE

*A*long with drawing, light and COLOR are also fundamental in watercolor painting. You have to understand color, know what you can do with it, know the three primary pigment colors, and know that by mixing these three colors you can make all the colors in nature. In order to master color, you also have to know about secondary and tertiary colors, broken colors, and color ranges.

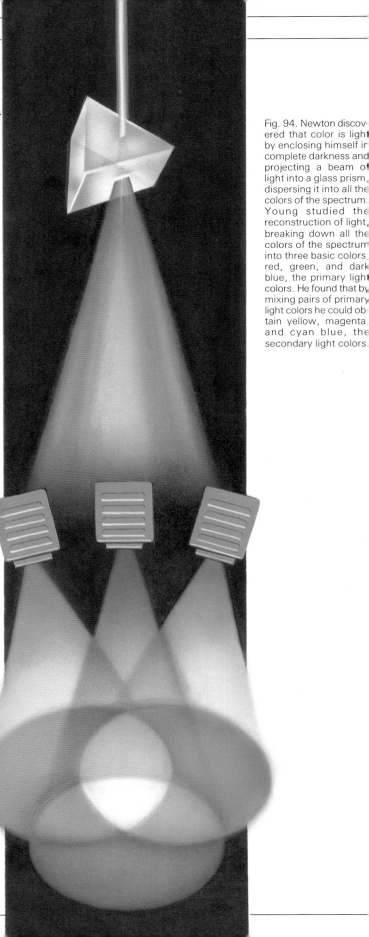

94

Color is light. Two hundred years ago, the English scientist Isaac Newton proved this theory by enclosing himself in complete darkness and intercepting a beam of light with a prism, thus dispersing the white light into all the colors of the spectrum. A hundred years later, another scientist, Thomas Young, experimented with colored lights. He projected the light of several lanterns—each lantern had a different color crystal to create the six colors of the spectrum—onto a white wall. By changing and eliminating beams, Young discovered that with only three colors, red, green, and dark blue, he could reconstruct white light. This explains what a primary color is, for, if all the colors of the spectrum can be broken down into just three, then these are surely the three basic, primary colors.

While reconstructing white light, Young also discovered that by projecting the red light beam over the green one, he obtained yellow, that the blue beam projected over the red produced magenta, and that the mixture of the dark blue and the green lights created a cyan blue. As a result, the three colors obtained by blending the primary colors are called the secondary colors.

Well, up to this point we have been dealing with light, beams of colored light, and dispersing and restructuring white light. We have learned that when two colors of light are mixed together, such as red and green, the amount of light is doubled and a clearer light is obtained, yellow. Physicists call this additive synthesis.

But, you cannot paint with light. When mixing pigment colors, you are taking away light. For instance, by mixing red and green, you get a darker color, brown. Physicists call this subtractive synthesis. Consequently, the primary pigment colors must be lighter. Still using the colors of the spectrum as our basis, we can say that:

Fig. 94. Newton discovered that color is light by enclosing himself in complete darkness and projecting a beam of light into a glass prism, dispersing it into all the colors of the spectrum. Young studied the reconstruction of light, breaking down all the colors of the spectrum into three basic colors, red, green, and dark blue, the primary light colors. He found that by mixing pairs of primary light colors he could obtain yellow, magenta, and cyan blue, the secondary light colors.

All the colors of nature with three colors

The primary pigment colors are the secondary colors of light, and the secondary pigment colors are the primary colors of light.

PRIMARY PIGMENT COLORS:
Yellow, magenta, cyan blue

By mixing pairs of these colors, we obtain the
SECONDARY PIGMENT COLORS:
Dark blue, green, red

By mixing secondary colors with primary colors, we obtain the
TERTIARY PIGMENT COLORS:
Light green, orange, violet, carmine, emerald green, ultramarine blue

This leads us to the next important conclusion: The perfect coincidence between the colors of light and the pigment colors means that you can create all the colors in nature by using just three colors, yellow, magenta, and cyan blue.

(At the top of this page, you can see the chromatic wheel, or table of pigment colors, in which appear the three primary colors (P), the three secondary colors (S) (obtained by mixing pairs of primaries), and the six tertiary colors (T) (obtained by mixing primary and secondary colors).

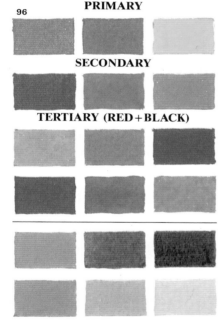

95

g. 95. Chromatic
heel, or color table,
howing the order of
rimary (P), secondary
), and tertiary (T)
olors.

g. 96. Pigment colors
rimary: magenta, cyan
ue, and yellow.
econdary: dark blue,
reen, and red.
ertiary: Orange, car-
ine, violet, ultramarine
ue, emerald green, and
ght green.
olor ranges: note the
d mixed with the black
he three tones in the
th row of the diagram)
nd the red mixed with
e white (at the
ottom).

g. 97. As a result of the
eories of Newton and
oung, it was discovered
at the three primary
olors could produce all
e colors of nature.

96

PRIMARY

SECONDARY

TERTIARY (RED+BLACK)

97

Color and contras

Figs. 98 to 101. The juxtaposition of complementary colors creates maximum contrast. By mixing complementary colors in unequal proportions, you can create a range of broken colors, as you will see on the following pages.

Fig. 102. Julio Quesada painted this landscape using a range of broken colors, "dirty" colors of a grayish tendency, creating contrasts through the juxtaposition and mixture of complementary colors.

Complementary colors are another major factor in color theory. In the figure on the previous page—the experiment with the three lanterns—you can see that white light is reconstructed by projecting the three primary colors of light on top of each other. Let us imagine now that the blue light is turned off. What will happen? Simply, that through the mixture of the remaining lights, red and green, you will get yellow. From this example, you can see that the yellow light is complementary to the blue in reconstructing white light, and vice versa. You will also realize that the complementary colors for the colors of light are also the same ones for pigment colors.

Yellow complements blue
Blue complements red
Purple complements green

From the chromatic wheel on the previous page (Fig. 95), you will see that complementary colors are always directly opposite each other.

Within a highly defined range of broken colors—dirty grays—Julio Quesada demonstrates the contrast of complementary colors in the watercolor reproduced below (sienna alongside blue and broken green, crimson next to dark blue, and so on).

98 99 '00 101

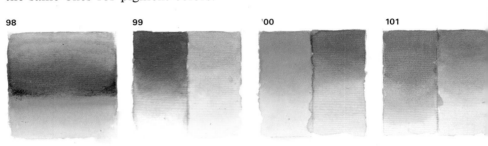

102

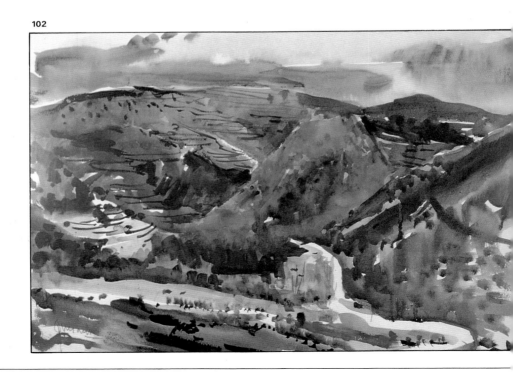

Painting with only four colors

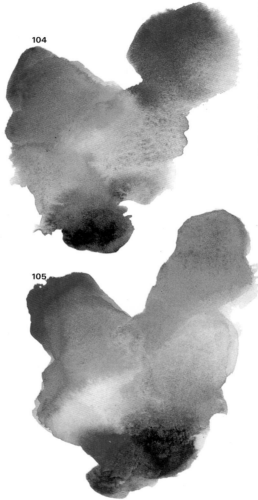

Figs. 103 to 106. Here, in these mixtures of Indian red with ultramarine blue and sienna with emerald green (Figs. 104 and 105), you can appreciate the wide range of colors and hues you can obtain and how you can use them to practically resolve notes and watercolors such as the ones reproduced on this page (Figs. 103 and 106).

As you saw on page 33, Julio Quesada keeps a total of fifteen colors on his palette, but when actually painting, he uses very few colors—no more than five or six. Among his favorite colors, which he uses frequently, are Indian red and emerald green. They are the initial colors he uses in many of his paintings and he heartily recommends them as basic colors "to begin a picture with a range of broken colors," as the artist explains. As he then emphasizes, "the fewer colors you use to paint a picture, the better the valuing and chromatic harmony of the painting."

You can admire the excellent results Quesada obtains using just four colors —Indian red, ultramarine blue, sienna, and emerald green—in the watercolors shown on this page.

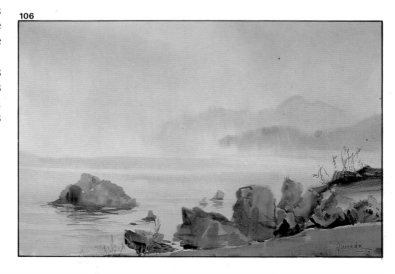

Mastering a single color

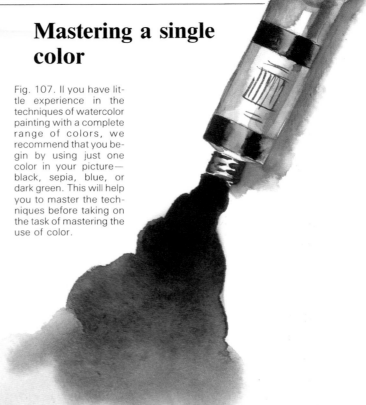

To begin to master your medium (to learn to draw with a brush, gradate, absorb, reserve, draw and paint without colors, that is to say, without the problem of mixing, matching, and harmonizing colors), we recommend the following exercise: to paint with only one color, just one blue or brown or just with black. For example, the painting below (Fig. 107) was painted with black India ink. The drawing was rendered with the "feeder" (a special piece of equipment for loading compasses and drawing pens), and the valuing and modeling was done with gouache and a paintbrush. This exercise will give you valuable experience before tackling the difficulties of painting and drawing at the same time.

Fig. 107. Il you have little experience in the techniques of watercolor painting with a complete range of colors, we recommend that you begin by using just one color in your picture— black, sepia, blue, or dark green. This will help you to master the techniques before taking on the task of mastering the use of color.

107

Painting a landscape with two colors

This demonstration deals with only two colors, no more, Indian red and Winsor green (similar to permanent green but a little darker).

You can see the two colors on this page, as well as the different colors and tones is possible to get from mixing them. Note that, besides saturating the colors, or watering them down, you can mix the two to obtain a wide range of colors, from a light warm gray (8) to a deep black (10), creating a greenish gray (3), a rather dirty sienna (2), and so on. You can see how this range has been applied to the painting in Fig. 116 on page 57. With these colors, Julio Quesada is going to paint a landscape of a semidesert-ed Mediterranean beach—"a wild place," as Julio says—where the only things you see are sand, the beach, strips of land, and the sea.

Quesada begins by drawing with lead pencil and a soft 2B grading pencil. This takes up little time and soon he starts to mix his two colors on the palette.

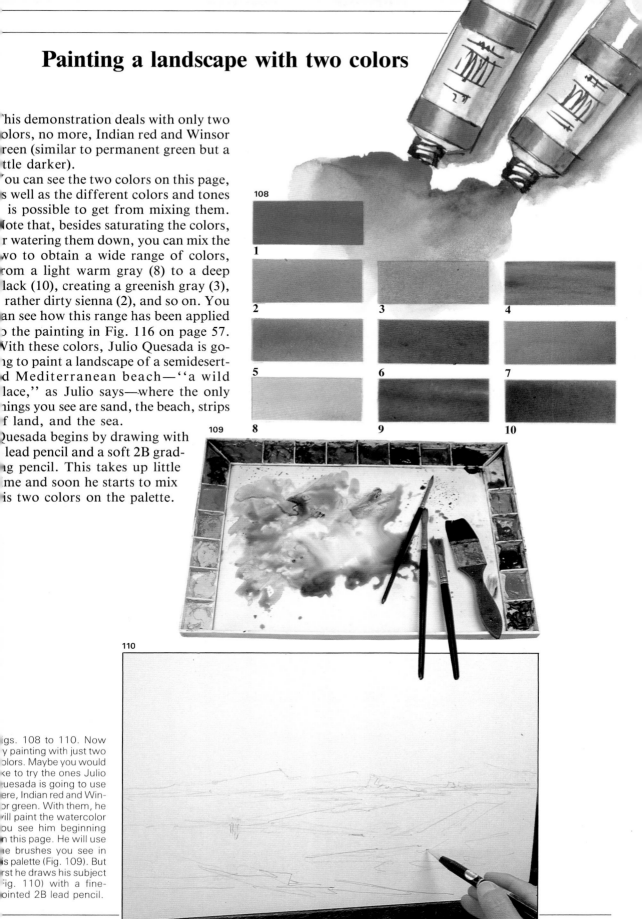

Figs. 108 to 110. Now y painting with just two colors. Maybe you would ke to try the ones Julio uesada is going to use ere, Indian red and Winor green. With them, he vill paint the watercolor ou see him beginning n this page. He will use he brushes you see in is palette (Fig. 109). But rst he draws his subject Fig. 110) with a fine-ointed 2B lead pencil.

Painting a landscape with two colors

Before painting, the first step is to wet the paper with water using a broad brush. Quesada waits for the paper to lose some excess wetness before starting to paint the sky with a cool gray, obtained by mixing the Indian red and the Winsor green. The area corresponding to the horizon he accentuates with a slightly warmer, redder tone (Fig. 111). Next, he paints the strip of sea with green. Still using his old flat-headed brush—an English sable-hair brush more than forty years old, as Julio tells us— he paints a number of stains representing the strips of land which break up the beach, using Indian red and a little green (Figs. 112 and 113).

As always, Quesada paints quickly and with a sure hand. And, despite the speed at which he paints, he meditates each brushstroke, thinking out each stroke. He draws the stroke in the air first, trying out direction and dimension with a movement of the hand, swiftly resolving it before painting and drawing. It is in this manner that he paints the reddish stains in the foreground.

111

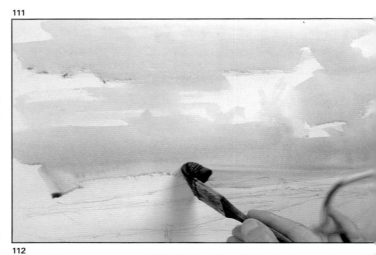

112

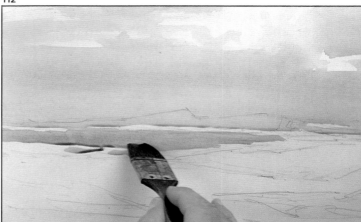

113

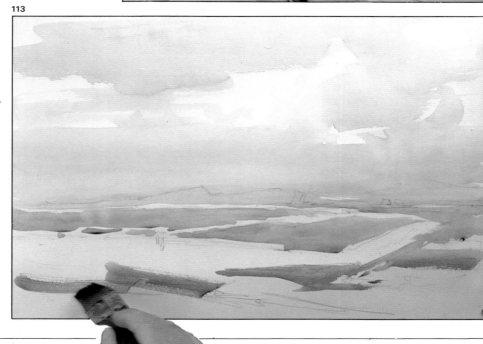

Figs. 111 to 116. The illustrations on these pages show the development of a watercolor painted with just two colors, which Quesada uses to obtain a wide range of tones and hues that complement and enrich the white of the paper. The painting gives the impression that it was painted with an infinite variety of colors.

Now, Quesada changes brushes, using a round sable-hair no. 12 to intensify the gray of the hills in the background. He mixes a reddish color, paints a few strokes in the foreground, then adds a few dark stains, as you can see in Fig. 114. He repeats these stains in several parts of the picture. Using the same dark sepia, he paints the strip of vegetation in the background, reinforces the color of the water, and then, with a touch of gray—broken siennas tending to red or green—he completes the painting, adding two figures as a finishing touch.

It is a good watercolor created with just two colors, in which the white of the paper plays an important role. We can sum up its artistic value by saying that it is a perfect lesson in synthesis when painting in watercolor.

Congratulations, Julio!

114

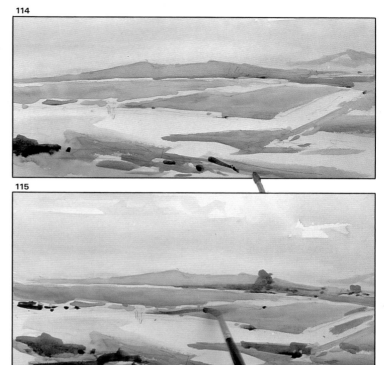

115

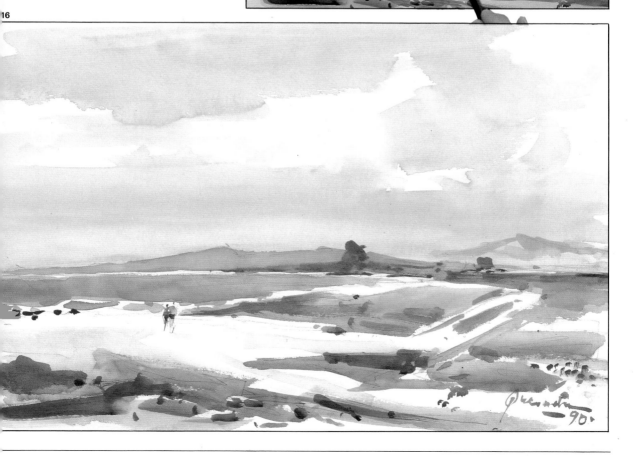

117

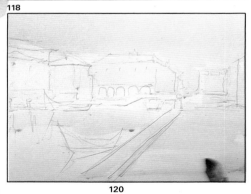

118

For this exercise, Quesada will use the three primary colors, lemon yellow, light crimson, and ultramarine blue, and Fabriano 18 × 12″ (46 × 31 cm), 140-1b. (300-gram) block paper.
The subject of the painting is Aveiro, a village in Portugal, called the "Portuguese Venice" by its inhabitants because of its rivers and canals.
First, Quesada draws the subject and

Figs. 117 and 118
Painting with just three primary colors, the pigment colors ultramarine blue, carmine, and lemon yellow, Quesada is going to show you how it is possible to create all the colors of nature.

Figs. 119 and 120
Quesada starts by painting the sky an orange color. Later, he will make it more grayish by adding ultramarine blue.

119

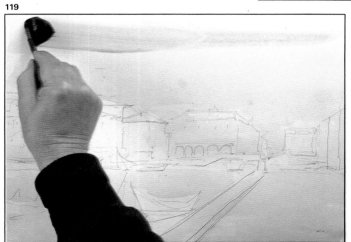

120

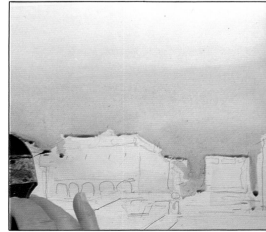

Painting a landscape with three colors

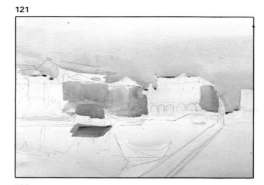
121

wets his paper. Using a flat brush to get rid of grease, he begins painting with the wet-on-wet technique.

He starts painting with an orange tone made from mixing lemon yellow and carmine. He also uses this color on some of the houses and on the pavement on the right (Fig. 118).

While the paint is still wet, Quesada paints over the sky with an ultramarine blue, graying that area (Figs. 119 and 120). Then he paints the shadows of the buildings (Fig. 121), and paints and builds up the reflections of the water. Next, he paints a layer of color over the promenade or pavement on the right, and paints the roofs with a predominantly carmine tone (Fig. 122).

You can see, at the end of this stage (Fig. 123), how the white has been reserved in the boats in the background and in the reflections of the water. Note, too, that the color range Quesada uses has a grayish tendency, of broken colors.

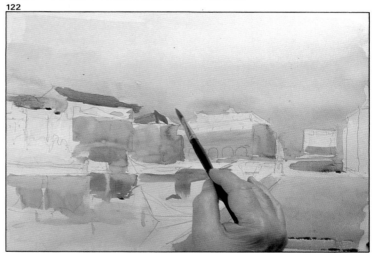
122

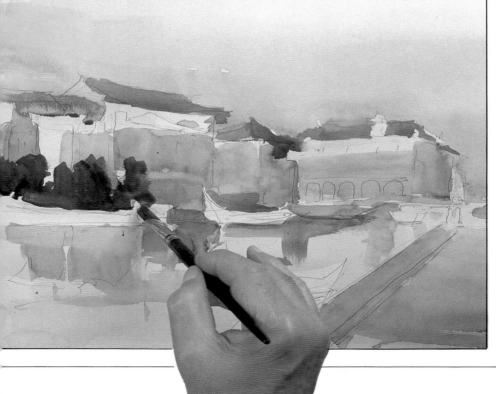
123

Figs. 121 to 123. Now, he is painting the houses in the background, the roofs, a number of stains to represent the reflection of the forms in the water, and the trees on the left.

124

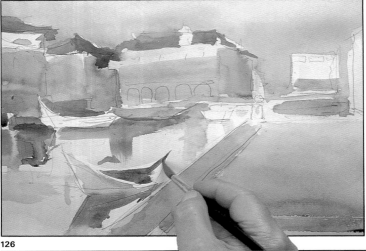

125

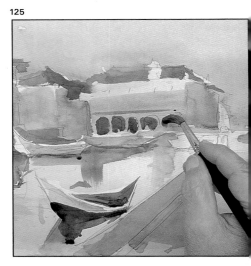

126

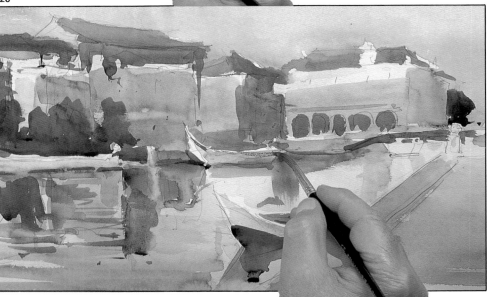

Figs. 124 to 127. Quesada paints the boat in the foreground and the porticos of the house in the background, highlights the lighter colors through contrast with the darker areas, and, finally, paints the pavement on the right.

Figs. 128 and 129. Opposite page: Quesada finishes the picture by emphasizing some areas: In the house in the center, a few intertwining strokes form the windows; a little yellow is added to the house in the background and to the one on the left; the red roof in the center is intensified; and now this watercolor painted with just three colors is finished.

127

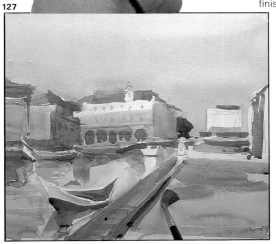

Now, Quesada's task is to paint and draw, to color and structure, and to bring out forms and colors. Note the reserve of the white in the rail of the boat in the foreground, the transparency of the area in shadow, and the black color Quesada has obtained by mixing the three primary colors (Fig. 124).

In Fig. 126, you can see how Quesada has painted the water of the foreground from the middleground. For the middleground, he mixed carmine and yellow, drawing and painting the movement and reflection of the water, making the ultramarine blue more predominant as he moved toward the foreground.

Having previously painted the porticos of the houses in the background, he now strengthens the color of some of the areas in shadow, brings out the form and color of the boats, highlights the whites by darkening depths, adds lights, reflections, and stains, and then returns to the walkway on the right (Fig. 127). He comes and goes, as if making up the time lost waiting for the paint to dry in one area, going on to the next, in a kind of feverish haste to see and paint everything at once.

He finishes the picture by darkening one of the houses in the center, and reserving the windows of the building (Fig. 128), using the carmine to darken the roof above. Then he adds a few touches of pure yellow in the houses in the right of the background.

128

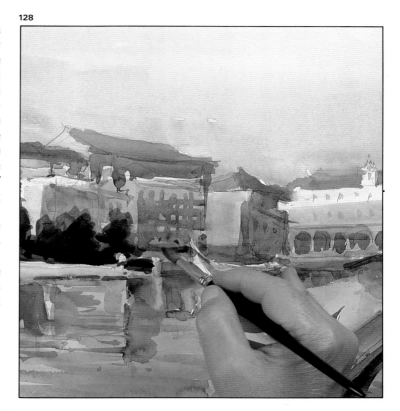

129

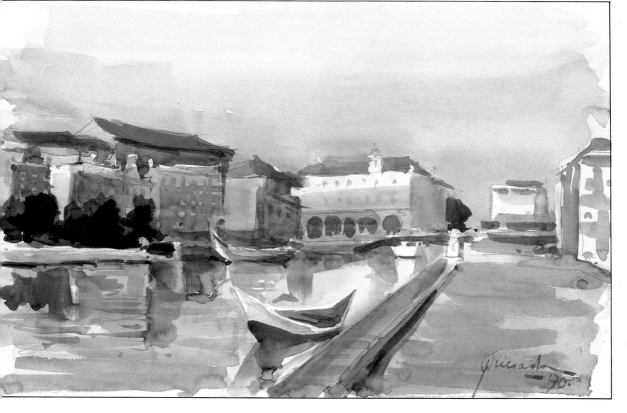

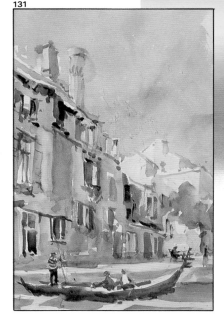

130

In all of Quesada's watercolors, there is always a combination of color that, for the most part, is created by the artist himself.

I say "for the most part" because, in theory, the harmonization of colors is provided by nature—the way light affects the subject. In the open air, at daybreak, the light takes on a cool, bluish tendency, at midday the tendency is warmer, and in the evening, the colors are orange, gold, and reddish tones.

However, this may be why Quesada accentuates the color tendency of the subject. For instance, he will paint with a dominance of blues if the tendency of the subject is toward a cool color range.

131

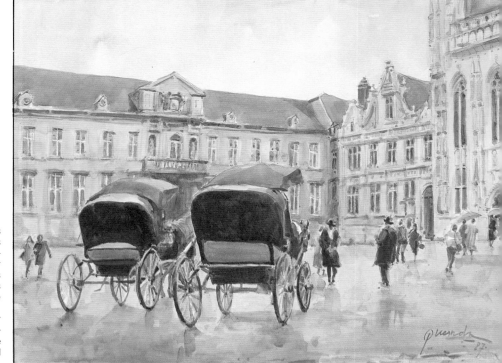

132

Figs. 130 to 132. Light is formed by all the colors of the spectrum, but, according to the time of day and whether the sky is clear or overcast, colors have a tendency to be either warm (Fig. 131), cool (Fig. 132), or broken. These tendencies determine how the colors of a painting will harmonize.

Harmonizing colors

The warm color range

This is a range characterized by a tendency toward reddish ochre, chiefly made up of the colors of the spectrum that you see in the illustration above (Fig. 133)—green-yellow, yellow, orange, red, carmine, purple, and violet.

But this does not mean that because greens and blues are not mentioned in this list, they cannot, like all other colors, be included in a painting with a warm color range. There must be a marked tendency toward yellows, ochres, reds, and siennas, but these and other warm colors can be mixed with blues, greens, and violets.

Quesada supplies a good example of this tendency in the watercolor reproduced on this page, in Fig. 134.

Figs. 133 and 134. In the warm color range, yellow, gold, and red tones dominate. These tones usually appear at dusk, when the sun is going down. In Fig. 134, the warm colors are evident in this watercolor by Julio Quesada.

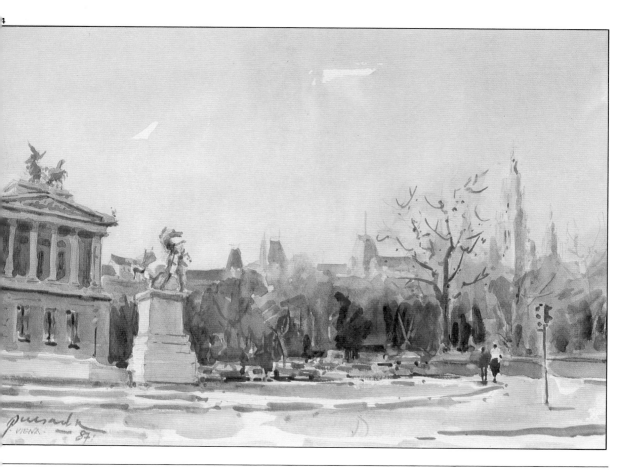

135

The cool color range

In the cool range, there must be a dominance of greens, blues, and violets. It is basically made up of greenish yellow, emerald green, light and dark blue, and violet.

As we said when discussing the warm color range, yellows, ochres, reds, siennas, and so on, need not be totally excluded from this range. These colors can be painted with a cool range, as long as they do not dominate or modify the color tendency too much.

The picture of a beach and the one of Venice on this page, both painted by Quesada, demonstrate a cool color range. In each painting, there is an intervention of warm colors—siennas in the beach scene and pinks and yellows in the Venice scene—but always with a cool, bluish tendency.

Figs. 135 to 137. The cool color range has a tendency toward blues, greens, and violets. These colors often appear in the early hours of the day and on cloudy days. The watercolors by Quesada, reproduced in Figs. 136 and 137, are fine examples of the use of the cool color range.

136

137

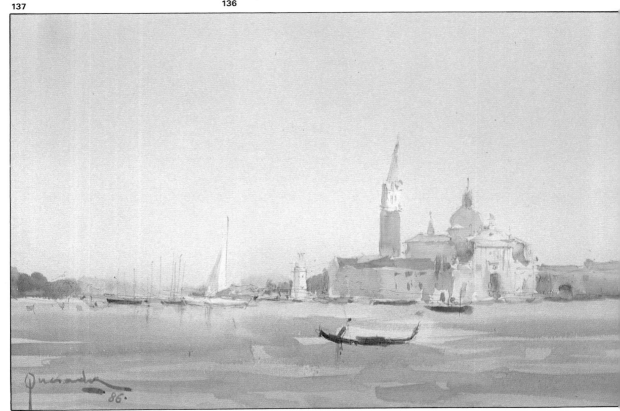

The broken (or grayed) color range
"Broken," in this case, refers to dirty, grayish colors. They hardly ever have the brilliance and saturation of clean, pure colors, yet they achieve a color harmony of extraordinary quality. This is the color range Quesada usually paints with. In theory, the broken color range is composed of pairs of complementary colors mixed in unequal proportions and grayed with white (in watercolor, the white is actually the white of the paper). Quesada, with a mixture of Indian red and emerald green, and the white of the paper, provides a perfect example of a painting created with the harmonization of broken colors (Fig. 139).

Figs. 138 and 139. The broken color range is also known as dirty or gray colors. This range is composed of the mixture of white (in watercolor, this is provided by the white of the paper) and complementary colors in unequal proportions, which produces grays and dirty colors. Broken colors can have a cool or a warm tendency.

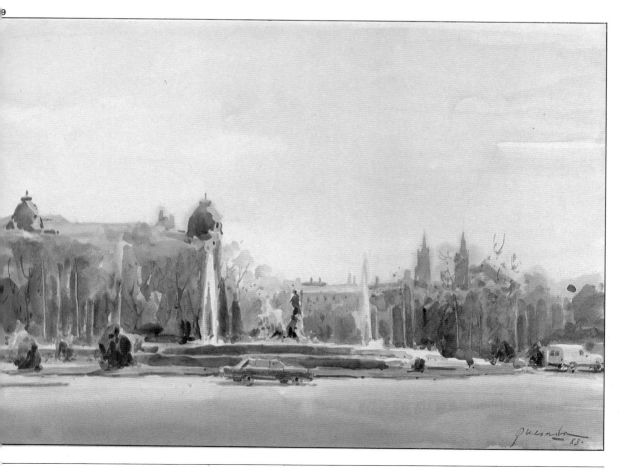

The colors Quesada use

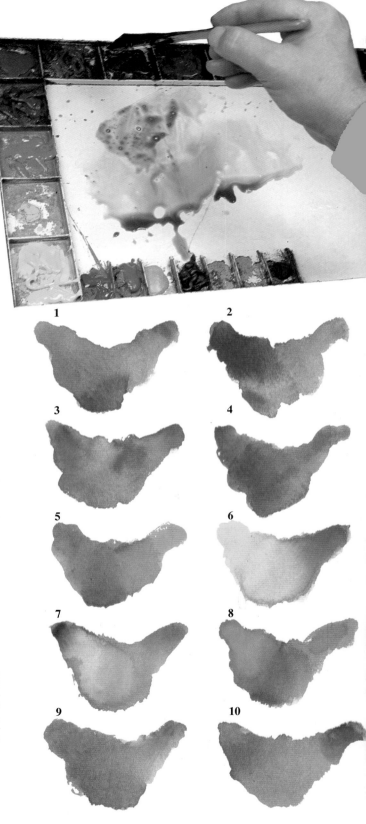

In the numbered illustrations of mixed colors on this page, except for the phthalo blue with permanent green (number 7) and the yellow with Indian red (number 6), all the mixtures are combinations of complementary colors, or very close to being complementary (see page 52).

The following are a breakdown of the mixtures:

1. Emerald green and Indian red
2. Ultramarine blue and Indian red
3. Cobalt blue and Indian red
4. Cobalt blue and light carmine
5. Emerald green and cadmium orange
6. Lemon yellow and Indian red
7. Phthalo blue and Winsor green
8. Winsor green and cadmium red
9. Light carmine and emerald green
10. Burnt sienna and phthalo blue

As you may have noticed, there is a lot of Indian red and emerald green, sometimes replaced by Winsor green—the two colors most frequently used by Julio Quesada.

The above list confirms what we have already mentioned— that Quesada uses, more often than not, a range of broken colors in his work. This is further demonstrated by the two watercolors reproduced on the next page, especially by the one at the top of the page (Fig. 142), which, with its impressive clarity and richness, was completed using just two colors—ultramarine blue and Indian red—the two colors mixed together in the gradation shown beside the picture.

Fig. 140. Here, you can see Julio Quesada's palette and the paints and mixtures he frequently uses. He has an evident preference for Indian red, emerald green, ultramarine blue, and light carmine—colors that complement each other when mixed in pairs, and produce grayish, broken tones and hues.

Fig. 143. Opposite page: A small seaport town painted by Quesada using a broken color range in a warm tendency. Note the mixtures of Indian red combined with greens and blues.

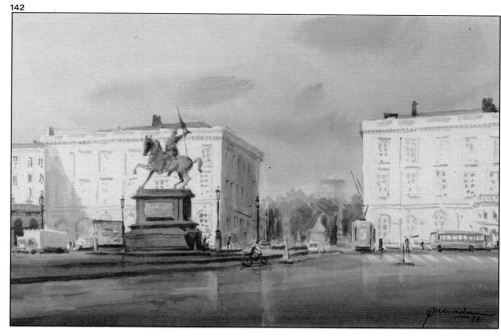

Figs. 141 and 142. Indian red and ultramarine blue are the main colors used by Quesada in this fine watercolor.

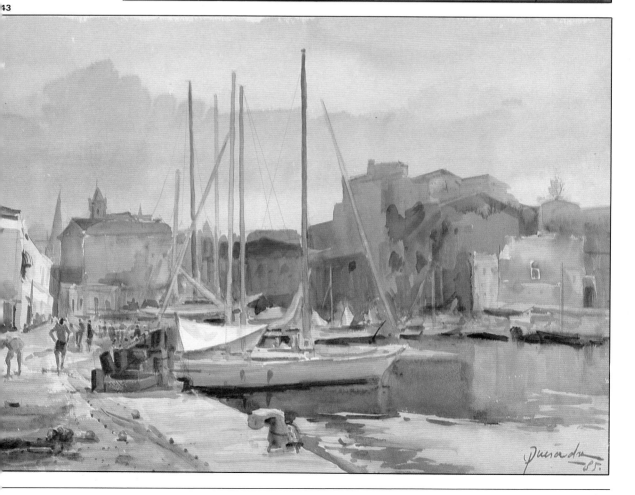

INTERPRETATION
AND
SYNTHESIS

There are two ways of painting. One is by depicting reality exactly as you see it, keeping strictly to the colors and forms of the subject. The other is by imagining and creating a reality that reflects a personal vision and interpretation of the subject. There is no doubt that the second way is the right way. True artists have always been distinguished for their ability to draw and paint their impressions and emotions as they stand before nature. Artists also have always striven to draw and paint in synthesis, summarizing and abbreviating. As you will see on the following pages, Julio Quesada is no exception to these principles.

The teachings of the impressionists

Figs. 144 to 147. The impressionists rejected realism and the grand composition. Instead, they returned to the "abbreviated manner" of Velázquez, Goya, and Turner. As a result, the basis of impressionism was the painting of subjects through interpreting and synthesizing forms and colors. Fig. 144. Berthe Morisot, *Carriage in the Bois de Boulogne*. Ashmolean Museum, Oxford. Fig. 145: Paul Cézanne, *La Carrière Bibémus*. Museum Folkwang, Essen. Fig. 146: Albert Marquet, *Notre-Dame Soleil*. Musée des Beaux-Arts, Pau. Fig. 147: Paul Cézanne, *La Montagne Sainte-Victoire*. Louvre, Paris.

During their time, Manet, Degas, Sargent, and many other artists visited the Prado Museum in Madrid to see the paintings of Velázquez. It is said that Manet studied the master's "abbreviated manner," and took it back with him to Paris. The painter Antonio Palomino, a contemporary of Velázquez, gave the name "abbreviated manner" to the way the master eliminated details, toned down outlines, and enveloped his forms in space to produce brilliant pictures, such as *The Spinners* and *Las Majas*. The writer Georges Jeanniot once said of Manet, "While it is true that he painted his subject, he never copied nature; his simplifications were masterful. Everything was abbreviated. He was interested in summarizing and synthesizing. He used to say to me, 'In art, conciseness is essential. The concise man makes us think, the talkative man bores us.'"

144

145

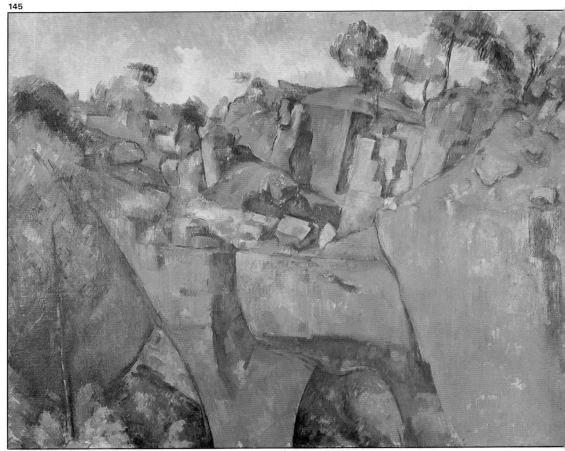

In the words of Paul Cézanne, all the impressionists strove "to free themselves of the slavery of making an exact copy of nature."

"Claude Monet," said Pierre Bonnard, "painted before his subject, but only for ten minutes. He did not allow the subject to get control over him." Bonnard also explained, "When I try to paint directly, scrupulously copying the model, I become absorbed by the details, and lose my initial idea of the picture. If this idea is lost, there is only the subject left, the model who invades and dominates the painter. From then on, the painter is no longer painting his picture."

All the impressionists learned that lesson. You have to interpret. You have to abbreviate to paint what you see inside, to paint your picture.

146

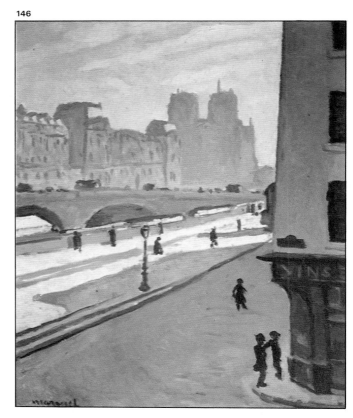

The process of interpreting and synthesizing

No, the paintings reproduced on these two pages are not the same. They are of the same subject, but painted four times in different ways. Can you see the differences?

For Julio Quesada, it is quite normal to paint the same theme four, five, or more times. Why? What is he trying to achieve, what is he looking for in this reiteration?

"I'm trying to perfect the technique, the interpretation and synthesis," Quesada explains. "As you know, in watercolor the artist must master spontaneity and freshness of finish, manage ease and sureness in the drawing, render well thought-out adjustments of whites and reserved forms, and so forth. This means you have to solve a number of technical problems that relate to drawing and painting, the absorption of water and color, wetting, and so on. All this is going on during the process of personal interpretation and synthesis."

Quesada continues, looking at one of his watercolors, "Some artists do a sketch, a preliminary painting, but I prefer to paint a definitive watercolor first... which isn't really definitive," and he stresses the word "definitive." "Analyzing the subject in depth, judging colors and forms, studying and planning reserves, trying out solutions of wet on wet, ... and then I paint a second watercolor, which for me is the first, putting all I have learned from the first study into it. Whether I paint another version, or more, after this second one depends on how much I like the subject and my need or desire to experiment."

148

149

Figs. 148 to 151. The desire to perfect the interpretation and synthesis of form and color is a constant in the work of Julio Quesada. It becomes such a major part of his way of painting that it is not unusual for him to paint the same subject two, three, five, or more times in his attempts to perfect coloring, brushstroke, spontaneity, interpretation, and synthesis.

50

51

Interpreting different subjects

As you can see by the pictures on this page, the same subject was painted three times. This allows Quesada to study the technical process of resolution and the synthesis of forms and colors in order to achieve a better picture.

Notice, in the two illustrations at the top of the following page, how he has painted the group of trees. They are depicted with a number of stains that are in perfect synthesis with the forms.

Finally, observe the splendid watercolor at the bottom of page 75 (Fig. 157). Quesada has painted the banks and water of a river, the trees, the earth, and the reflections, with a language that comes close to the abstract in its daring interpretation, but which retains its figurative representation thanks to the explicit synthesis of colors and forms.

152

153

154

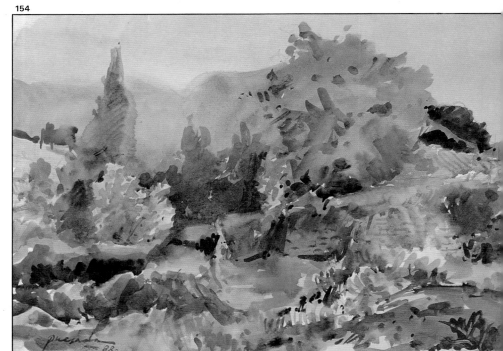

Figs. 152 to 154. The same subject was painted three times in watercolor. The study of synthesis in form and color is apparent.

Figs. 155 and 156. Abstract stains which, observed separately, reveal no concrete form (Fig. 155) are transformed into perfectly identifiable trees when they are incorporated into a landscape by Julio Quesada (Fig. 156).

Fig. 157. The interpretation and synthesis of form and color in this river are so effective that, at first sight, it appears to be an abstract painting.

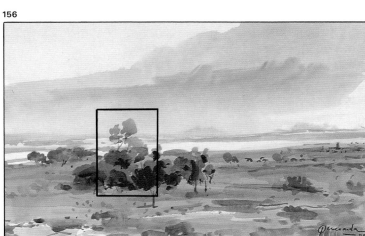

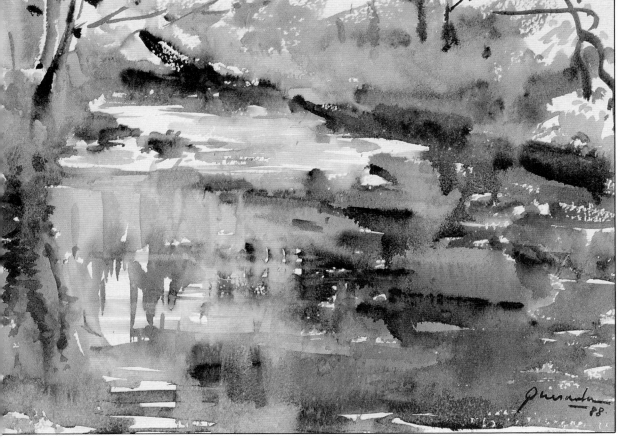

Skies and reflections in water

Many artists place extraordinary importance on the resolution of the sky in a landscape. "I always begin with the sky," said the impressionist Alfred Sisley, adding, "The sky is not simply a background; blue is the brother of the plain, and the sky is as full of plains as is the earth." In the opinion of John Constable, who made many watercolor studies of clouds and skies, "The sky is the source of light which governs the picture and is its first organ of expression." For Julio Quesada, the sky is always the first step when painting a landscape. "I always start with the sky, too," he says as he paints one of the notes that illustrate this page (Fig. 158).

"And, if you look, the skies I paint almost always determine the color range of the picture. In this picture, with this sky, I'm going to paint with a range of broken colors."

"What advice would you give to an amateur who wants to paint good skies?" I ask.

Quesada answers, "First, do not rely on improvisation, draw the clouds linearly and exactly. Second, really study and notice the direction of the sun and the lighting of the sky. Finally, study the clouds thoroughly before starting to paint, study which areas are in shadow, the tones, values, and the contrast."

On the subject of reflections in water, Quesada takes as examples the two watercolors shown on the following page, explaining, "As you know, water is like a mirror; it makes an exact copy of anything above it or beside it, reflecting the same shape and practically the same colors —the one peculiarity is that the color in the reflection is more intense."

Figs. 158 to 160. As you will see on the following pages, in the section devoted to practice, Quesada always begins painting a watercolor with the sky, which generally, as he points out, determines the color range of the picture. These notes amply demonstrate this point.

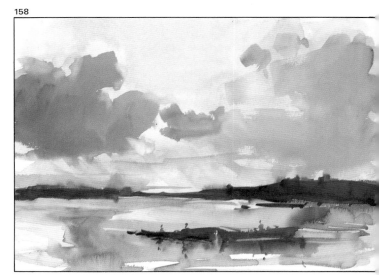

158

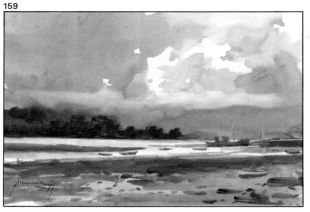

159

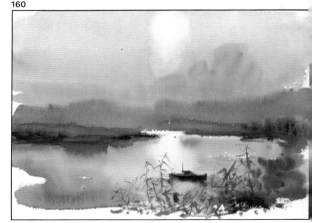

160

161

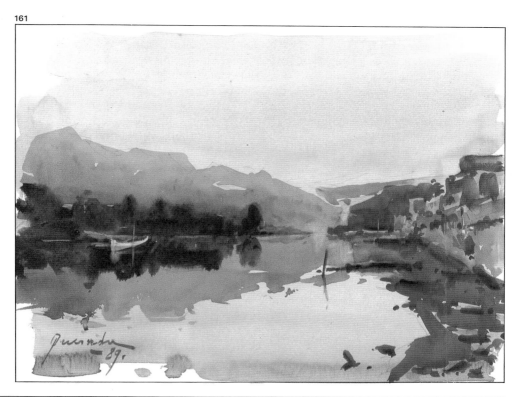

gs. 161 and 162. A onderful color note and magnificent watercolor which you can appreciate Quesada's treatment of forms reflected water. Note the simplicity and spontaneity in ese paintings.

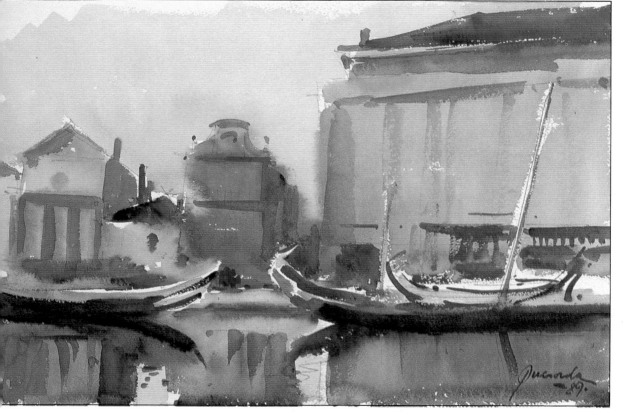

Quesada's trees

Here are some examples of trees and bushes painted by Julio Quesada. There are no leaves, hardly any branches, just stains and abstract forms which, "out of context," as in Figs. 163 and 164, do not depict what you understand as the shape of a tree or a bush. But when they are seen as part of the landscape, as in Fig. 165, they are trees, they are shrubs, they "have" leaves and they "have" branches.

They are trees and bushes whose form and color correspond to a personal interpretation, an "abbreviated style." This idea echoes a comment made by Van Gogh in a letter to his brother Theo, referring to Gainborough's painting style: "I have found a paragraph about Gainsborough which makes me want even more to 'get straight down to work,' without getting sidetracked or obsessed by small details, to try to capture

Figs. 163 to 165. Juli Quesada paints in th structure and color c trees through a series c stains. These stains however, refer to th subject so that, whe they are incorporate into the picture, they ar no longer abstract, bu depict exactly what the are supposed t represent—trees an bushes in a country lanc scape.

163

164

165

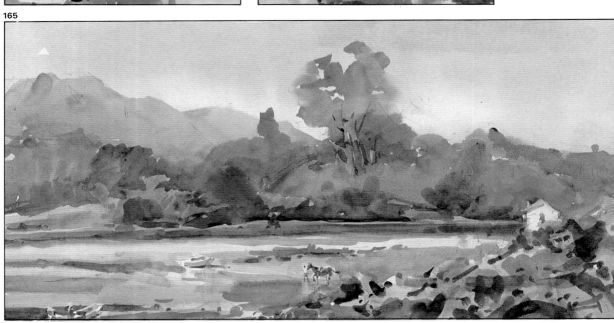

the overall effect, looking at the picture as one observes nature: taking it in with just one look.''

According to Van Gogh, the artist must take into account the effect of the whole. This effect is found in Quesada's paintings where you observe the shape and color of trees.

167

66

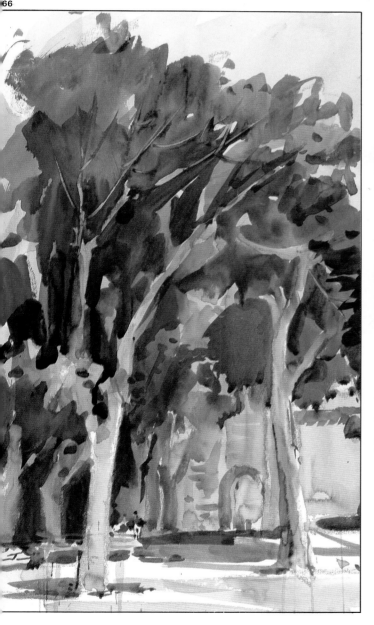

Figs. 166 and 167. You can appreciate the versatility of Quesada in these two pictures that show a remarkable contrast in definition and finish. In Fig. 166, Quesada painted with a wide brush and thick paint; there is a feeling of freedom in both thought and gesture, and a relaxed, self-assured language is employed. In comparison, Fig. 167 is an idyllic, charming note that also includes trees, but painted with a thin brush and thin paint.

Quesada's figures

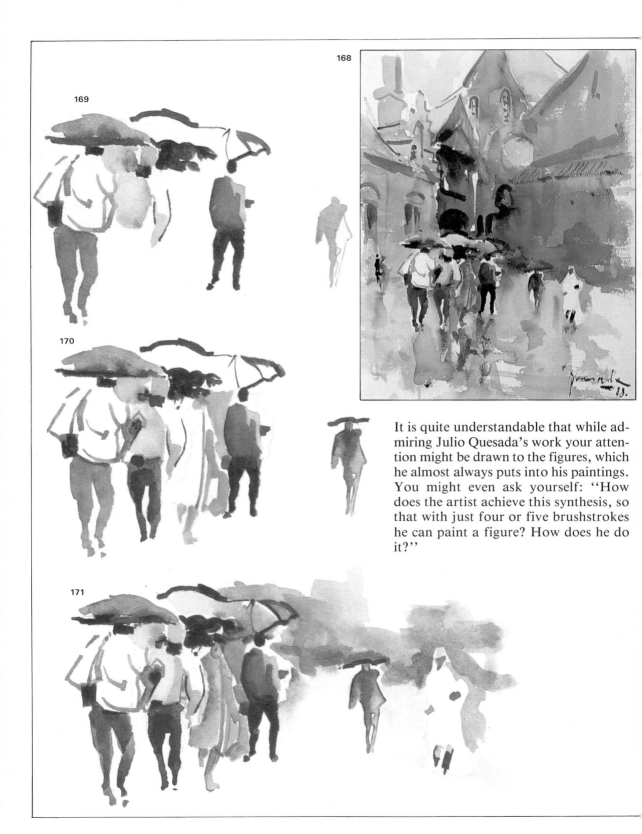

It is quite understandable that while admiring Julio Quesada's work your attention might be drawn to the figures, which he almost always puts into his paintings. You might even ask yourself: "How does the artist achieve this synthesis, so that with just four or five brushstrokes he can paint a figure? How does he do it?"

gs. 168 to 172. As well
s being an excellent
ainter, Julio Quesada
so draws magnificent-
, which explains why
e can include a number
 figures in his pictures
ithout using a prelimi-
ary drawing. He paints
nd draws at the same
ne, capitalizing on his
xtraordinary memory
r form and his proven
bility for synthesizing.
ith a dot (the head) and
o vertical lines (the
gs) joined to an irregu-
 form (body and arms),
uesada can depict a
gure either seated,
anding, working, or
alking.

Allow me to explain: For figures, Quesa-
da usually uses a round no. 4 brush—
sometimes a no. 8 or an even bigger
brush, just as long as the paintbrush has
a good pointed tip. And with no prelimi-
nary drawing, no pencil or ballpoint, he
paints directly onto the paper with his
brush.

Usually, Quesada does not plan the
placement of his figures. But sometimes
when he is painting a background or a
middleground, he saves a long space
where he will paint figures.

Quesada's figures are created from a
spontaneous, easy, good-humored way
of painting. It is the result of Quesada's
great mastery in form, dimension, and
proportion, in drawing, and in synthesiz-
ing. When seen in the context of the pic-
ture, even if close up and out of the
context, the figures are just a few
simple-colored shapes laid down with the
paintbrush. Take a look at how they de-
velop step by step, through the enlarged

illustrations on the previous page. Try
to interpret the forms that make up each
figure, so that you will better understand
how they were conceived. Observe and
study the figures in the painting by
Quesada on this page (Fig. 172), too. It
is a picture of an old quarter of Madrid,
showing the traditional houses of
Castile.

I recommend that you paint some figures
like these, with the same synthesis of
form and color, using a no. 4, a no. 8,
or an even bigger brush, just as long as
the paintbrush has a good pointed tip.

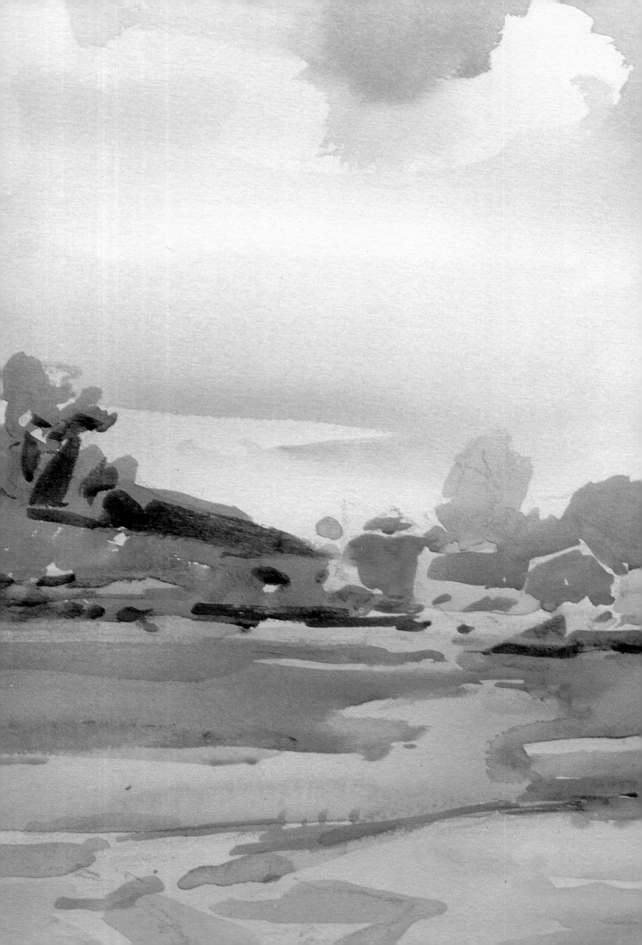

PAINTING LANDSCAPES

In this last chapter, you are going to see and learn the step-by-step development of five landscapes painted in watercolor by Julio Quesada made especially for this book. Two notes were painted by him in record time, some fifteen or twenty minutes, and three watercolors that took him two or three hours to complete. You will be able to follow the process Quesada used through almost one hundred photographs taken while he worked. From the drawing of the subject with a ballpoint pen or wax crayon, right up to the adjustment and contrasting of tones and colors, passing through the stages of painting backgrounds, skies, and reserves—all done while drawing and painting at the same time.

Before we begin, you will be able to see and study Quesada's techniques of painting wet on wet, how he mixes colors on the paper itself, when and why he rejects smaller headed brushes, and the techniques he uses to open and reserve whites.

Quesada's techniques

173

174

175

As a general rule, Quesada dampens his support and drawing paper after drawing his subject "to get rid of any grease that may still be there," he says. "And I wet the paper to start painting with the wet-on-wet technique."

He wets the paper with a flat brush, as broad as the one you can see him using in Fig. 173. Then he waits three or four minutes before testing the wetness with the back of his fingers, as shown in Fig. 205 on page 90, where he is painting a landscape of Majorca. Sometimes he gauges the wetness of the paper by looking at it sideways, as in Fig. 174. "When your paper has absorbed the water, and the surface is no longer very shiny, but almost matte, then that is the moment to start painting," explains the artist. And that is when Quesada begins to paint with the wet-on-wet technique, with the paper almost dry, so that he can immediately reserve some whites and "open" others with his brush, as in Fig. 175.

Mixing colors on the support itself

Quesada usually does not test colors on a separate piece of paper, as many artists do. "I see the mixtures on the palette," he explains, "or I try a color with a brushstroke on the paper itself, and correct by mixing it with another color if need be." And that is exactly what he does, sampling and mixing paints on his paper, then toning and darkening the original color, as you can see in Figs. 176 and 177.

Quesada's paintbrushes

Naturally, Quesada has a varied collection of brushes, thin ones, thick ones, round ones, flat ones, and so on. "Yes, but I hardly ever use thin brushes, I generally use thicker ones, starting with a no. 8 as the finest, going up to a no. 12, 14, or 20, and flat brushes $^3/_4''$ (2 cm), 1 $^1/_8''$ (3 cm), even 1 $^5/_8''$ (4 cm) wide." He emphasizes his point by saying, "With thin brushes you get thin watercolors with no strength and no soul."

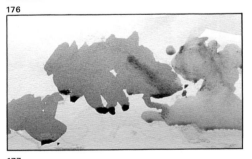

176

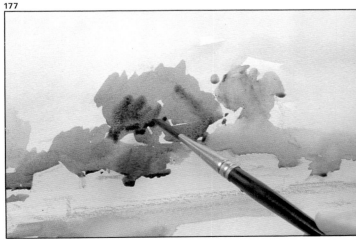

177

Figs. 173 to 175. For the wet-on-wet technique Quesada wets his paper before painting. This helps to rid the paper any grease remains.

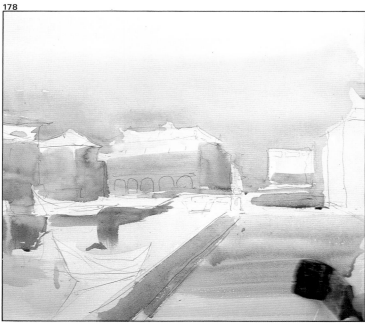

178

Proof of this statement is shown in Fig. 178 on this page, where you can see a photograph taken while Quesada was painting a watercolor in only three colors (the painting shown on page 59). Note the use of the flat brush to define medium-size and even quite small forms.

Opening and reserving whites

Quesada, like most watercolorists, uses the trick of scratching with his fingernail when the paint is still wet to "open" white outlines on a darker background (Fig. 180). But, besides this trick, Quesada also puts in whites by reserving spaces and forms, either by leaving them blank from the outset or by lifting up, or absorbing, the color, which is achieved by applying a clean brush—squeezing it out beforehand—to the spot. Quesada's way of cleaning out his brush is really unique: He squeezes it between the thumb and forefinger of his left hand (Fig. 179) with such expertise and experience that he can judge and adjust the right amount of moisture to leave so that he can absorb the exact amount of color he wants—solely through the pressure and touch of his fingers.

At times he may use a sponge to absorb color, but he never uses a cloth, blotting paper, or liquid gum (frisket), which he thinks is totally unsuitable for pure watercolor techniques.

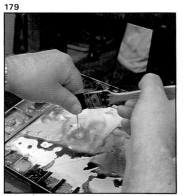

179

180

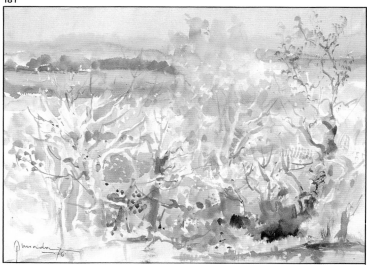

181

Figs. 176 and 177. Mixing and forming colors, as well as correcting and resolving tones on the support itself are much-used techniques in Quesada's style of painting.

Fig. 178. Julio Quesada prefers to paint with thick brushes. He believes that thin brushes produce "thin" pictures, over finished and dead.

Figs. 179 to 181. The artist does not recommend liquid gum when reserving whites and highlights. In this respect, he is a traditional painter. "Reserves have to be planned and made from the moment you start painting. But, you can also "open" whites by squeezing out your brush and absorbing a color, or by scratching a color out with your fingernail. But these are the only ways to do it."

Painting watercolor notes

Fig. 182. Quesada begins by drawing or sketching his subject with a black ballpoint pen. His drawing is made up of very fine lines, suggesting a simple theme: sky, land, and a few trees among thickets.

Figs. 183 and 184. After wetting the paper, he paints with a very light carmine and red, then adds a little cobalt and burnt sienna at the top, allowing the colors to blend together.

Fig. 185. Here, he paints in an ultramarine blue strip, which outlines forms at the bottom of the picture and makes the top part more hazy, suggesting a distant background.

Fig. 186. Now, he paints in the areas he had previously reserved, allowing color stains to spread over into the wet areas.

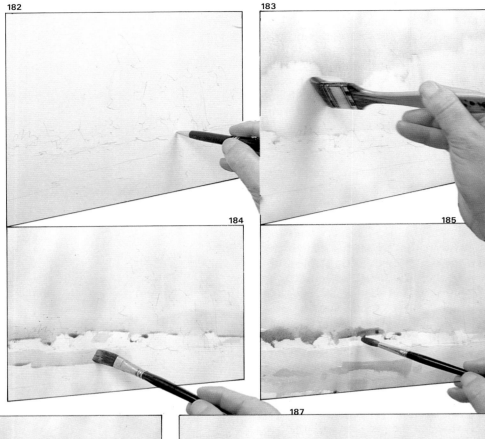

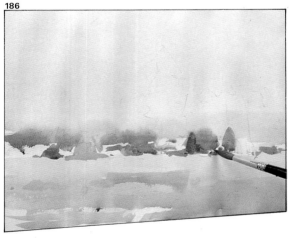

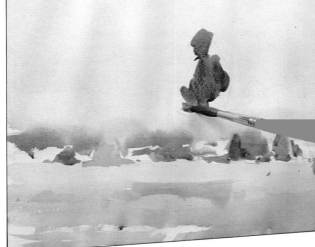

Fig. 187. Now, daringly, he paints a tree whose silhouette stands out against and contrasts with the light gray-blue sky. He resolves the tree with a dark gray, obtained through a mixture of carmine, blue, and green.

First, Quesada is going to paint a color note for us. His subject is a flat landscape containing a group of trees. He is going to use a Fabriano block of fine-grain paper. He starts by sketching his subject with a black ballpoint pen, trac-

ing a fine outline just for reference purposes. Then, he stains the paper with a wide, flat brush dipped in a pale, thin wash of carmine and red. At the top of the picture, he adds cobalt blue and burnt sienna.

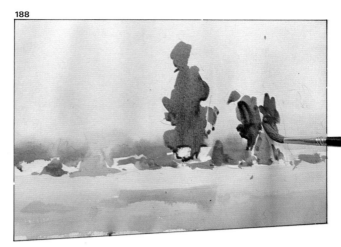

188

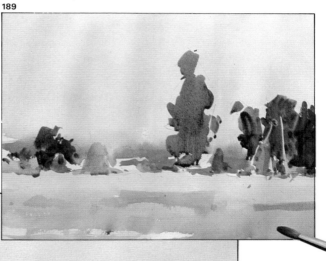

189

He paints wet on wet, gradating and harmonizing colors by absorbing them with a brush, which he first squeezes between his fingers. In the lower part of the picture, the meadow, he paints with a mixture of cobalt blue and carmine, to which he adds some leftover grays. Still painting on wet, he immediately paints an ultramarine blue above the horizon to suggest thickets made hazy through distance. Using the round brush, he starts to stain in brighter colors, to define the vegetation and trees in the foreground. Rapidly, with a sure hand, he stains the trees whose outlines stand out against the sky, adding a little black. Then, he scratches at various parts of the foreground with his fingernail to open a few whites, branches, grass, or reeds. The note is now finished.

Figs. 188 and 189. Julio Quesada continues working with a warm gray that comes close to sienna, using large strokes to create the form of the tall trees on the right. Over the first stains, he superimposes stains of green and more black, so that the trees stand out even more clearly against the background. Then, he emphasizes the color of the field with long brushstrokes of carmine.

190

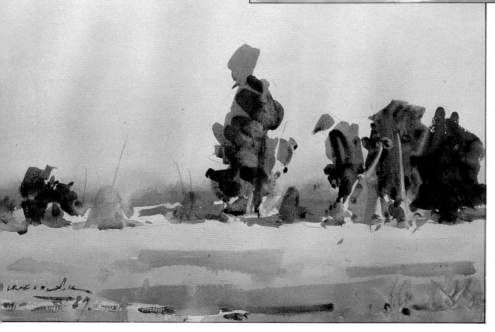

Fig. 190. This is how Quesada's quick note looks finished. He has stained his paper freely and deliberately, changed some of the tones wet on wet, and painted with saturated colors. As a finishing touch, he has scratched open white areas with his fingernail while the paper was still wet—dragging the pigment over the paper—producing the branches and trunks of the trees and the grass in the foreground.

Painting a Majorcan landscape

191

192

193

194

195

196

197

Our guest artist Julio Quesada is going to paint another watercolor note now. This time his subject is a small beach that brings back many pleasant memories to him. He decides to draw with his red ballpoint pen. As always, he draws without taking the pen off the paper. For this note he is constructing the planes and the geometric forms of the beach huts, and getting the dimensions, proportions, sizes, and perspective of his picture. He begins by painting in the background, the sky. First, he paints a band of cobalt violet; then, he immediately paints in a strip of yellow followed by a viridian, creating a type of rainbow, the colors harmonizing through the clarity of their values. Next, he paints the white house with an almost transparent violet, and colors the hut on the left an almost pure cerulean blue. He will paint the shade when the watercolor is dry. With a touch of darker color, he daringly paints another wall on the right, then he paints the area of the pathway and the vegetation in earthy colors and greens. With blues mixed with green and carmine, Quesada paints the shadows of the huts farthest away. Now, he turns his attention to the roofs of the huts and the little squares in the background, which he paints with reds, carmines, and violets. With those same colors, but more tempered, he paints the little hillock and the sand, moving into the foreground, so that the warm and cool colors have a contrasting effect. Finally, he strengthens the shade and the volume of the hut in the foreground with ultramarine blue, and makes a few warm brushstrokes on the sand.

198
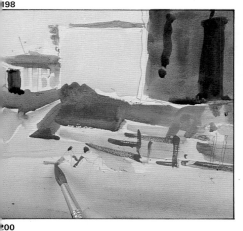

199
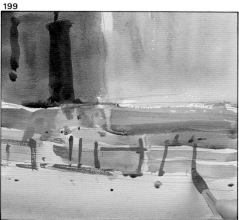

00

201
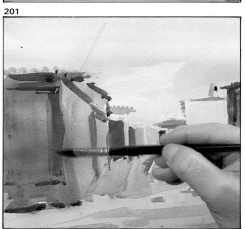

02
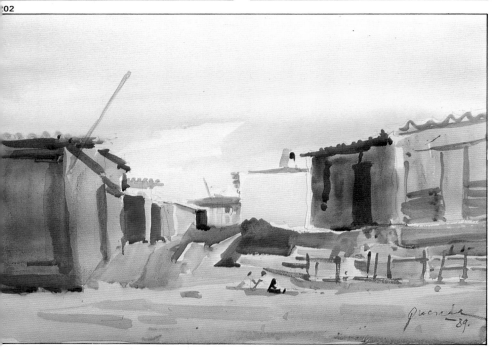

Fig. 191. Quesada has made a fairly detailed drawing with a red ballpoint pen, hardly lifting it from the paper, looking time and again at his subject, giving his work proportion and dimension.

Figs. 192 to 194. First, Quesada wets the paper and then paints in three strips of color—cobalt violet, yellow, and viridian.

Fig. 195. With a mixture of ultramarine blue and burnt sienna, he stains a square, a wall, which has not yet been harmonized with the rest of the picture.

Fig. 196. The state of the painting in this figure shows the daringness of Quesada while drawing and painting at the same time. There are strong contrasts and abstract stains that do not, as yet, bring out the volume of the subject.

Fig. 197. As you can see, Quesada has added a variety of bright, intense colors, resolving the overall effect as if building up a jigsaw.

Figs. 198 and 199. Here, Quesada adds figures with simple, quick brushstrokes. Then, he concentrates on the fence, which he had reserved earlier.

Figs. 200 and 201. He strengthens the colors of the shadows cast by the huts with blues—ultramarine, either diluted or applied directly onto the paper in its pure form.

Fig. 202. The note is finished. With a variety of color, Quesada conveys the volume of the forms on the beach, the light surrounding them, and a vital, lively sensation.

Painting a seascape in watercolor

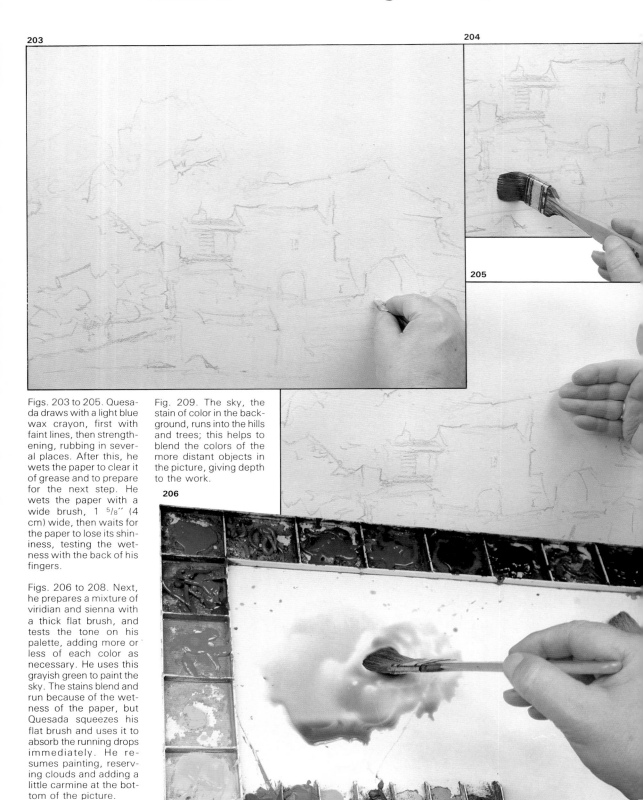

203

204

205

206

Figs. 203 to 205. Quesada draws with a light blue wax crayon, first with faint lines, then strengthening, rubbing in several places. After this, he wets the paper to clear it of grease and to prepare for the next step. He wets the paper with a wide brush, 1 $^5/_8$'' (4 cm) wide, then waits for the paper to lose its shininess, testing the wetness with the back of his fingers.

Figs. 206 to 208. Next, he prepares a mixture of viridian and sienna with a thick flat brush, and tests the tone on his palette, adding more or less of each color as necessary. He uses this grayish green to paint the sky. The stains blend and run because of the wetness of the paper, but Quesada squeezes his flat brush and uses it to absorb the running drops immediately. He resumes painting, reserving clouds and adding a little carmine at the bottom of the picture.

Fig. 209. The sky, the stain of color in the background, runs into the hills and trees; this helps to blend the colors of the more distant objects in the picture, giving depth to the work.

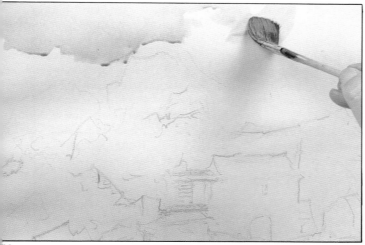

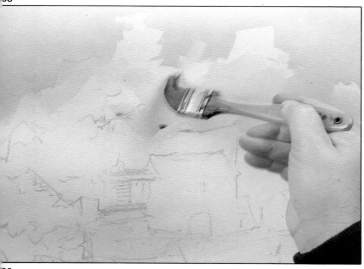

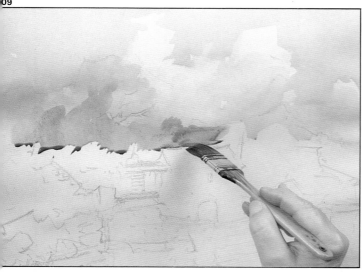

Quesada is now going to produce a different kind of work for us than the first two. His intention is to "paint a picture," rather than a note. He is going to use a 140-1b. (300-gram) paper made by Fabriano. Our artist starts to draw using a blue wax crayon, tracing a sure, instinctive line, a line that spreads over the whole paper without stopping. At some points, he presses harder, drawing with more strength, indicating in his drawing the value of each element in the picture. He draws a few reflections in the water, placing the houses and the general masses of trees and mountains. Quesada uses the wax to prepare the paper to be painted over in watercolor in the next step. He situates "points of interest" where the water will run, creating, as the artist explains, "a picturesque effect." Depending on the amount of wax, the water will go through the paper in varying degrees. But, why the color blue? Quesada has chosen this color thinking of the overall harmony of his theme, so that colors will blend through contrast. Since he is going to paint with warm colors, he decides to draw with blue.

Wetting the paper with a flat brush, Quesada then tests the wetness of the paper with the back of his hand, deciding to wait while it dries a little. He mixes viridian and sienna and begins to stain the sky, reserving a number of whites for the clouds. To this, he adds sienna and carmine stains, so that the grayish color takes on a pinker, warmer tone. He is careful about how much water he uses as he works, absorbing drops—always after squeezing the brush with his fingers, a manual, sensitive control, which makes it seem as if he is modeling the sky with his fingers.

Next, he prepares a mixture of cobalt blue with burnt sienna, getting a dark, broken green with which he stains the masses of the trees and hills. This color blends with the color of the sky, giving a suggestion of distance and depth to the picture.

Blue and sienna

Fig. 210. Note how, with this flat brush, which seems unsuitably large, Quesada really draws, reserving small forms such as the chimney of the white house.

Figs. 211 to 213. Quesada stains a number of areas, except the houses, using a variety of mixtures of cobalt blue and burnt sienna—all the intermediary tones, warm and cool grays. He joins the stains, then paints over them, sometimes using pure burnt sienna. There are also a number of reserves in all the small areas that will represent lights, an important point to remember when painting in watercolor.

Quesada is really "drawing" with the grayish color you see in the illustrations below, reserving and outlining some of the forms that occupy the same ground as the houses. But the strange thing is that he draws with a large flat brush, "oversized" even for the size of the paper.

He adds more cobalt blue and more sienna to the warm, greenish gray mixture which he still has on his palette, obtaining a whole range of colors—from blue to sienna, from cool to warm, with an abundance of broken colors among them. Using all these tones, he defines the entire background, as always reserving a number of whites, harmonizing, blending, and shading. The background is one great mass of richly hued color, in which you can now begin to intuit its vegetation and the hills in the distance. Quesada prepares the mass of trees on

the left with the same cool and broken tones of colors, and now you can see how the blue wax is starting to blend with the watercolor. Now, he continues working with sienna and burnt umber, painting the reflections in the water. At the bottom of the picture, in the water, Quesada mixes cerulean blue with burnt sienna to create a luminous, purer, "bluer" area in the painting.

With a wide flat brush, with which he can paint large, square or rectangular strokes, he adds more stains to the water area—mixing his colors on the paper, letting them blend together, and adding a little ultramarine blue.

These large stains, with their harmonized yet powerful definition, represent the colors of the sky. After achieving this, our artist dips his brush in water and proceeds to unite and freshen up the brushstrokes he has just made, the water area.

210

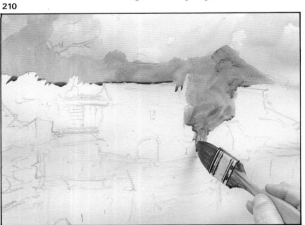

211

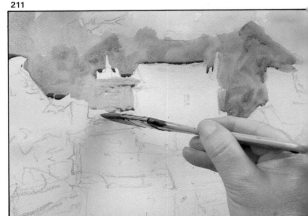

212

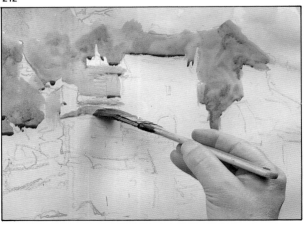

213

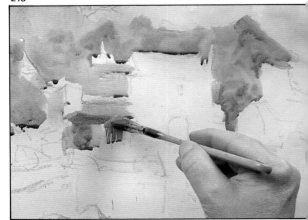

Look at the watercolor at the end of this phase. See how Quesada has painted the whole picture in one sitting. You can see that the artist prefers to resolve painting through stains, which at present make the painting seem more abstract than figurative or with defined forms. Note, too, that Julio Quesada has worked to harmonize colors from the outset. As you have seen, Quesada achieves color harmony with a limited range of colors.

214

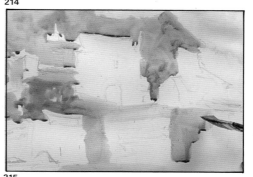

215

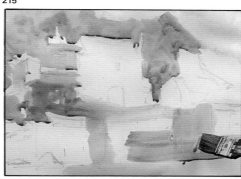

Fig. 216. As the picture stands at this point, it is interesting to note the variety of color the artist has obtained from a base of just two colors, blue and sienna. The stains are still very pale, with equal values, which leads us to believe that Quesada will paint by "raising" the color little by little, building up layers of paint.

Figs. 214 and 215. Quesada mixes cerulean blue and sienna to stain the water area at the bottom of the picture; it is a purer, less gray, and bluer color. Then, he mixes again, obtaining violet grays, filling the area of the sea with wide, smooth, watery strokes of the brush—at first vertical, the painting over them with horizontal strokes.

16

Construction and reflection:

Fig. 217. Julio Quesada changes brushes, choosing a no. 12 sable-hair round brush to reserve some of the branches of the trees with dark-colored, controlled strokes.

Fig. 218. Continuing this task, with very dark tones of umber and green, he adds small brushstrokes to construct shadows and volume.

Fig. 219. At the end of this step, you can see the beginning of value and color contrasts. You could say he has now placed the darker and the lighter colors in his picture. The definition of forms is truly pictorial; Quesada is painting with his eyes half-closed, just defining values.

217

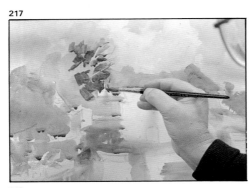

218

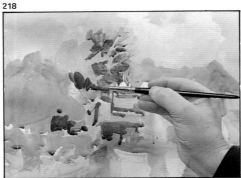

In this stage, Quesada works with a thin flat brush, dipped in sienna and dark green, reserving branches in the tree on the left with the color he used for the background. Then, he indicates the volume of the crown of the tree and scratches in more branches with his fingernail. The colors he uses now are more intense, saturated, even though they are still from the same color range. With a round no. 12 brush, he uses fine, short strokes to interpret the forms of details. He reserves the white of the house, and "draws" the door with a spot of viridian paint.

Quesada's techniques

Quesada's way of working is to paint in one area for a while; then he moves on to another area to give the first zone time to dry. In this phase, he is still using the same color range, continuing to mix broken colors. The contrast of value

219

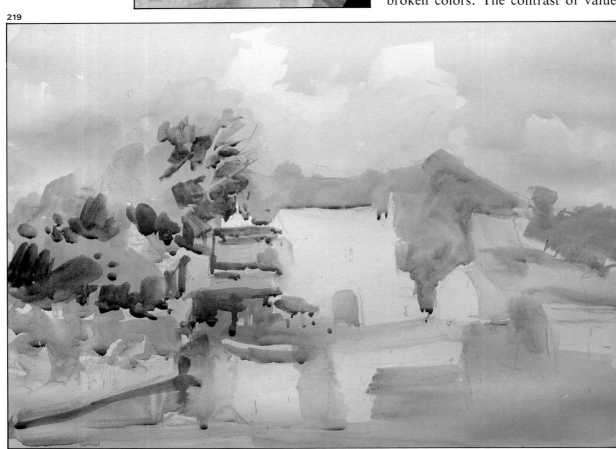

gives form to the first layer of grayish staining, whereas the small stains add a pictorial effect as well as help to construct the forms and volumes of the landscape. Quesada's brushstrokes are now deliberate; he uses them to graphically depict the water and its movement. He achieves a special effect with some rippled, broken blends of color, outlining the boats with long, fine strokes of strong colors—blue, violet, and black. Around the house he paints a zig-zag line that blends into the background. The dark colors he uses, blue and an almost black umber, create a line that divides the land from the sea and then stretches outward, blending and flowing into the water and becoming a reflection.

220

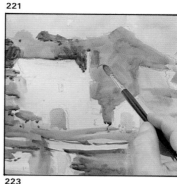

221

222

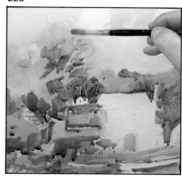

223

Figs. 220 to 224. Now, Quesada is working on the intermediary values, with small stains of colors in the same color range. Here and there, for instance, in the reflection of the boat, he uses pure blue. In Fig. 224, volume, the values of light and shade, and the construction of forms is practically complete.

224

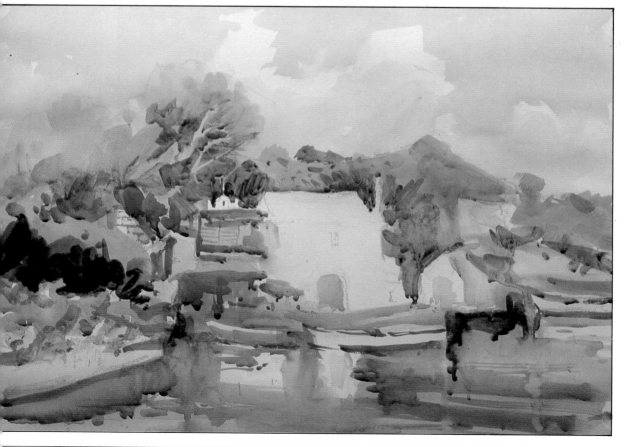

Covering over "holes"

Our artist now paints with short, round, intense strokes, with round stains like drops of paint. Some tiny figures appear in the picture; they are distinguished through the relation of the small stains, which Quesada has painted with his round no. 8 brush. A master of visual contrasts, Quesada's painting is now made up of stains and dots. The loose, vague brushstrokes are united through their association with one another, through rhythm. This is a manner you might call "impressionist" or abstract, but which is in fact pictorial—building up recognizable forms to produce an accessible landscape.

He constructs the shadow of the white house and the lines on the roof with bluish grays. With a very light carmine,

while others now appear much lighter. This is a painting of fine synthesis, of subtle harmony. There is relatively little paint but a fair amount of layering of stains. Now, Quesada adds a number of thick, saturated brushstrokes, using little water on his brush, to define boundaries; he is drawing more than painting.

Next, a few accents in the water, bright points and reflections in the calm sea. With a wet brush he rubs at dry stains, blending them more into the picture. Quesada has completed the work with a limited number of clean colors—cobalt blue, ultramarine blue, cerulean blue, Indian red, viridian, carmine, and sienna. Nothing else. To end this section, here is a phrase from a Nobel Prize-

225

Fig. 225. He paints in a figure or two to express proportion in the left-hand section of the picture. With three spots and four lines of lively color, the figures are complete. Quesada has achieved a splendid synthesis.

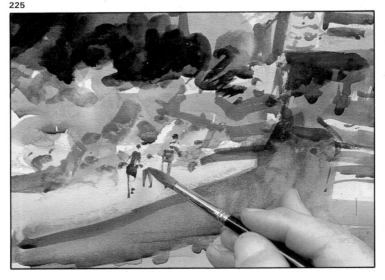

226

gradating it until it is almost a grayish blue, he paints the socle of the house. Then, still using these grays and warmer ones, which are watered down, he goes over the parts he has left unpainted (the white reserves in the vegetation) so that there is not as much white "making holes" in the picture. As a result, Quesada is able to clearly differentiate the values of the houses and the boats. From time to time, Quesada puts his little finger to the paper to make sure that it is dry enough. He continues valuing, some parts become more shaded

winning Spanish poet, Juan Ramón Jiménez, that Julio Quesada quoted to me: "Touch it no more, for thus is the rose."

Fig. 226. Quesada has strengthened some of the reflections in the water, has stumped a color or two, and is now signing his watercolor.

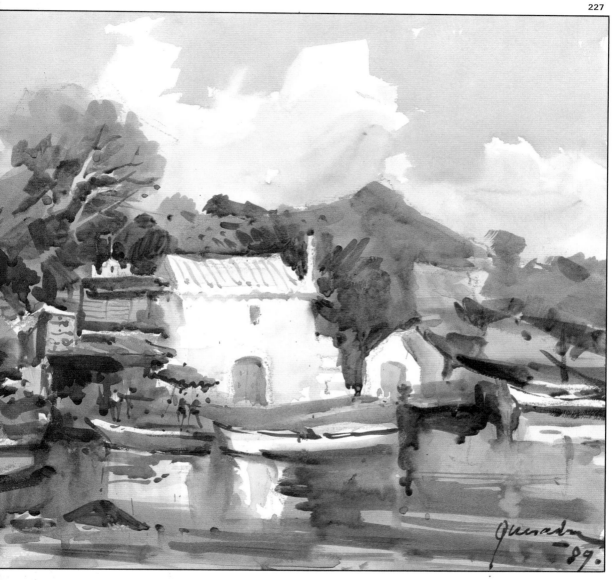

Fig. 227. The finished painting is marvelous— loose and suggestive. When you look at the picture as a whole, the brushstrokes blend and portray forms. One of the techniques used toward the end was to cover over some of the whites, which remained be- tween the colors of the vegetation and the water, with a fine layer of paint, a very light, tem- pered color. This helps to define the true white areas of the picture— the houses and the boats. You might think that us- ing only a few colors in a painting would make the picture lose force and form. But Quesada has resolved this dilemma by using infinite techniques and graphic resources, all this with just a few colors. Try painting with a few colors yourself—it is a truly excellent exer- cise.

Painting a seascape in watercolo

228

Figs. 228 and 229. Quesada has decided to use a red ballpoint pen to draw his subject, perhaps because of the bluish, cool tones of the seaport he is going to paint (Fig. 228). As al-· ways when preparing to do a watercolor, he draws in a loose, linear manner. The drawing unites and establishes relationships among various elements of the picture.

229

Fig. 230. Before starting to paint, Quesada cleans his palette, which is dirty from the previous painting. He always works with a clean palette, abhorring unplanned mixtures. Julio prefers to decide on his own mixtures.

230

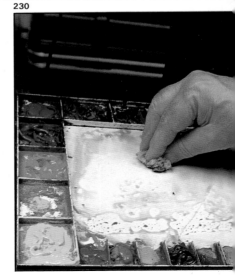

Quesada is now going to begin a new watercolor with a different subject: a seascape of fishing boats in a seaport. He starts by carefully cleaning his palette with a damp sponge. He studies his subject—the model—and the block of white paper, and looks back to the subject, as if mentally positioning the structure of the drawing. Then, he takes out his four-colored ballpoint pen from among his things and begins to draw. Without taking his pen from the paper, he draws easily and loosely, producing a linear sketch of all the elements his picture will contain.

Wash

He starts off by wetting his paper, using a wide flat brush. Then, he waits for it to dry a little, testing the wetness with the back of his fingers. He squeezes and pinches the brush between his thumb and forefinger before going over the horizon line with it, absorbing and drying. For the first color, he uses a viridian mixed with Indian red and cobalt blue on the sky, producing a warm, broken grayish green. With a warmer gray, a sienna, obtained by mixing in a little cadmium red, he works on the horizon of his picture. He stains everything deliberately with the green mixture, to which he adds more and more blue—the stains do not create borders or outlines. All the while, Quesada is reserving whites that correspond to the boats; he is even painting the parts of the boats in shadow with the green, which has now become a tone of blue.

With a tempered blue, he finishes this first layer, which includes the whole background, the sky, and the sea. Though the blue is a cool one, the overall atmosphere is warm, Mediterranean. With his brush, he absorbs water to create more reserves among the elements he is now painting, such as the smoke and the buildings. He is actually drawing in negative, absorbing paint as he draws.

231

232

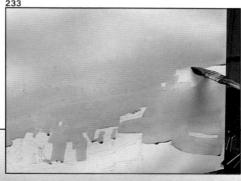

233

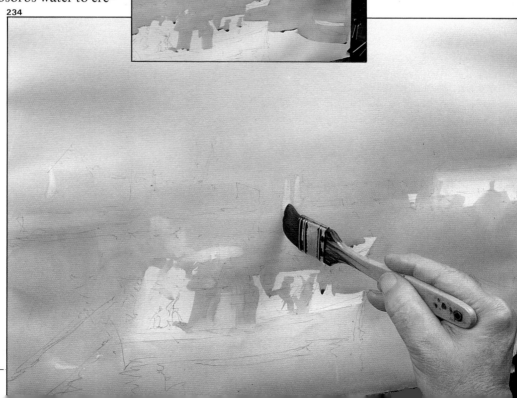

234

Figs. 231 to 234. In this series of four photographs, you can see how the artist stains practically the entire paper, using light tones, over which he will later paint layers of color. But this overall staining gives unity to the background, a deliberate harmony to the whole picture. We could even say that he immediately starts off by achieving a feeling of atmosphere that is just right for a seascape. He reserves just a few whites for the boats and the figures, but they are very much at random and undefined. The color he uses for staining in this stage is a green, which is almost a blue, with a touch of cadmium red in some areas. Notice how Quesada absorbs paint with his brush here and there, producing stumped whites.

Contrast

In this stage, Quesada mixes ultramarine blue and carmine, dips his brush in water, and with this transparent but rather dark gray-violet tone, he stains the forms that stand out on the horizon. He synthesizes them until they form a whole. Valuing the objects against the sky, he outlines them according to the atmosphere, which is cloudy and hazy, the result of the combined effects of humidity and heat. This is what is known as atmospheric perspective.

With a thin, flat brush tinged with the same color, Quesada adds a layer of rectangular stains to the background; then, he moves to the left-hand side of the picture, absorbing and painting with longer strokes, creating transparencies. Now, he mixes a metallic gray from cobalt blue and burnt sienna, adding more blue to paint the forms made by the spirals of smoke over the boat on the left-hand side. The color he uses now has a bluer tendency, containing more ultramarine blue, and with it he interprets and synthesizes the boats in the middleground. He draws them more than paints them, for he is constructing and structuring their forms with the flat brush, painting over them with an almost pure ultramarine blue. Next, he mixes this blue with ivory black to paint the boat in the foreground, making it contrast with the background. By separating the two planes, he is able to obtain suitable volume for the foreground through strong contrast with the background. With a round no. 8 brush, he now adds a figure using the same color diluted with water. Adding cadmium red to the color mixture to obtain a brown, he paints more figures on the boat, which are resolved totally through synthesis. The figures are made up of tiny stains, abstract dots, and brushstrokes that are united by color and outlined against the blue background. Then, as if in need of wider movement, Quesada uses broad brushstrokes to paint the outline of the dock on the left of the picture.

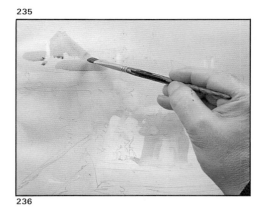
235

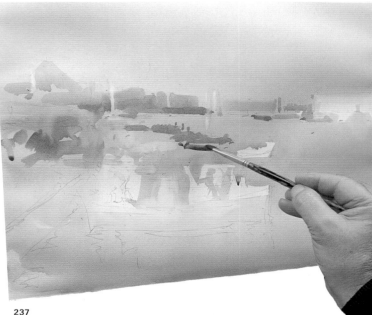
236

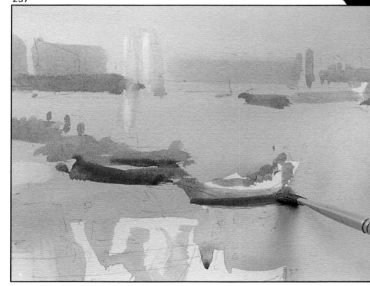
237

Figs. 235 to 237. With a rather tempered grayish blue, he begins to stain around the horizon line. He gradually paints down to the lower area of the picture; as he does so his color becomes a purer blue. In the background, the values are practically uniform; the stains are more diffused blending with the still wet first layer.

Figs. 238 to 241. These illus-
trations show how Quesada
almost completely constructs
the boat in the foreground. He
uses the white reserve for the
lights, adds black in the shade,
draws the boat, and paints in
some figures with warm colors.

Fig. 242. This second phase of
the painting shows you the ex-
pressive capacity of synthesis
when it is applied correctly and
well. Quesada has used just a
few different tones, but the
stains have been placed at the
right distances: In the fore-
ground, there is greater con-
trast; in the middleground there
are plainer colors; and in the
background, there are light,
tempered grayish tones. You
can already see the sea, some
reflections in it, and a thick
brushstroke of ultramarine blue
which represents the dock.

238

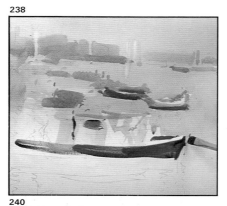

239

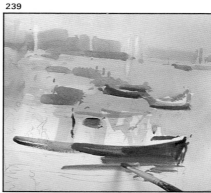

240

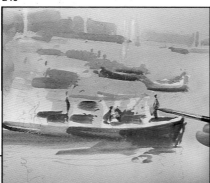

241

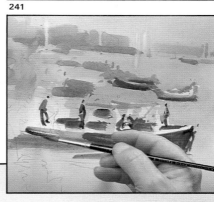

242

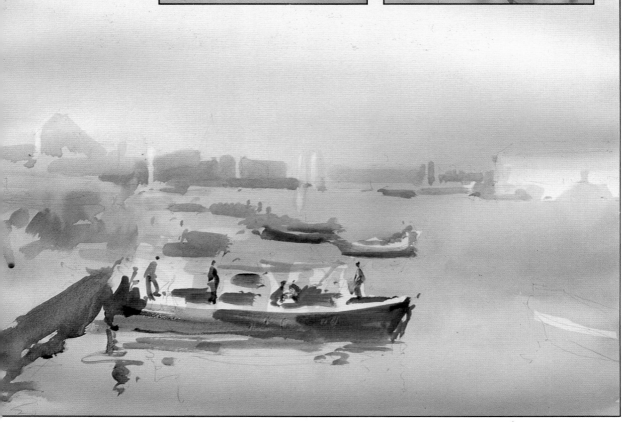

Structure

Fig. 243. Quesada paints over the dock and the boat with blue. Then, he immediately dips his brush in water and paints the same area with this dilution, stumping both the color he has just applied and the previous one, creating a blurred effect, the smoke.

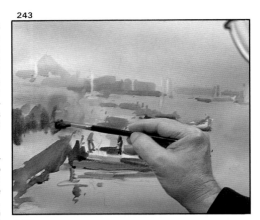

243

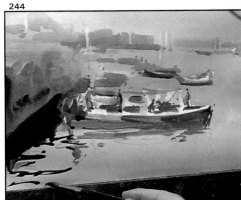

244

Fig. 244. He adds a layer of almost pure black to the shadow of the dock; then, he applies the same color to the water, to paint-draw a reflection with wavy, sensual brushstrokes and a drop or two of paint.

Figs. 245 and 246. Quesada continues to work on the reflections in the water, depicting its undulating movement and the different hues—the grays of the water and the cool blues of the reflection of the boat in the foreground, He seems to let his brush go, allowing it freedom to paint as it pleases; but this is not really the case, for Quesada controls every stain, every color, and every form.

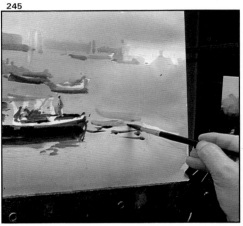

245

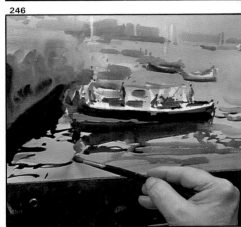

246

For this final phase, Quesada paints with a dark blue—cobalt blue and ultramarine blue—to complete the less-defined, hazy area over the dock on the left-hand side. He allows his paint to run, allowing it to find its own place and its own limits in the picture. This run begins to create reflections in the water, echoing the color of the sky and the sea.

Ultramarine blue and black, these are practically the only colors Quesada uses in the foreground—under the boat and in the water—to draw and structure the reflections. The black of these reflections is dark, dramatic in its strength, essential for defining the backlighting in the painting. Quesada then dilutes this black a little, applying it in long, fresh, rippling brushstrokes, which vary in width according to how hard Quesada presses the brush onto the paper. These strokes denote movement and define the structure of the boats in the background. He continues constructing with direct, short, tiny strokes, emphasizing less-defined strokes.

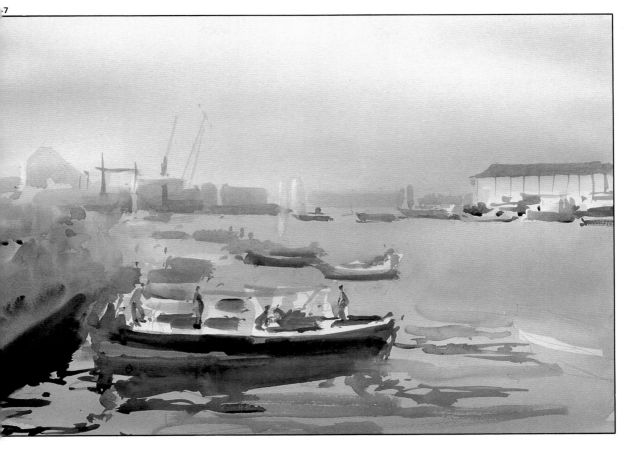

Finally, he paints the building on the right, starting with the roof, where he uses carmine, cobalt blue, and natural sienna to define the structure and shape of the walls. With tiny but intensely colored stains, he continues to define the horizon on the right side of the picture —the group of boats in front of the building.

Fig. 247. In this photograph of the picture, you can appreciate the artist's labor. He has strengthened the area of the horizon on the right—painting in the warehouse with carmine— and has added a number of touches in the foreground, to show the multicolored effects of the boats. Then, he precisely valued the rest of the horizon, also drawing in the cranes and darkening some of the buildings. As you can see, the foreground offers appropriate contrast to the backlighting, which forms the illumination for his subject.

Balance and synthesi

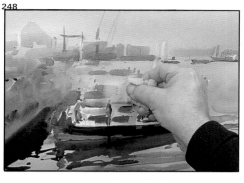

Quesada is now working with a clean sponge, squeezing it out and absorbing color from the column of smoke above the boat. He achieves a wonderful suggestion of the transparency of the elements made through this smoke. Then, he goes back to the building in the background and adds a fine layer of yellow mixed with carmine and sienna, obtaining a kind of dirty yellow close to ochre. Going back to the smoke, Quesada

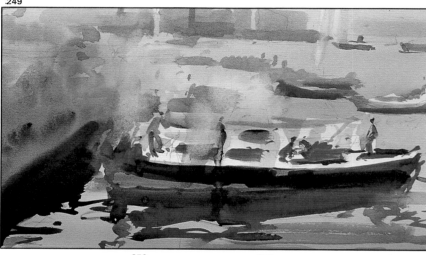

Figs. 248 and 249. Julio Quesada paints the smoke coming from the boat, where you can see the fishermen frying fish. Or, more correctly, he does not paint but unpaints, using a small natural sponge. First, he wets the areas to be worked on; then, he waits for the water to dilute and mix with the paint. Next, with a dry sponge, he absorbs the paint-soaked water, achieving the rubbed effects you see in the picture—the swirling whites that really look like smoke over the boat.

paints over it to structure its form. He paints around the smoke with cobalt blue, allowing the edges to blend together, giving further definition to its volume. Returning to the left-hand area of the background, he puts another layer of color onto the sea, darkening its tone in the foreground with broad horizontal brushstrokes that define the movement of the sea, the waves. Now, he turns his attention to the water under the boats in the middleground, darkening their reflections before drawing and structuring the forms of the boats in the rear, which are also in the middleground. Ultramarine blue and ivory black predominate now; they are applied in layers over the lighter colors that were painted in earlier. Notice how this process has helped to define and create volume in the boats. The next step is to work on the reflections in the water and the boats in the foreground.

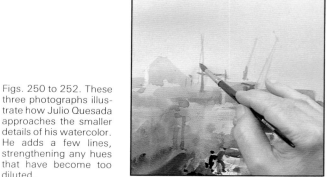

Figs. 250 to 252. These three photographs illustrate how Julio Quesada approaches the smaller details of his watercolor. He adds a few lines, strengthening any hues that have become too diluted.

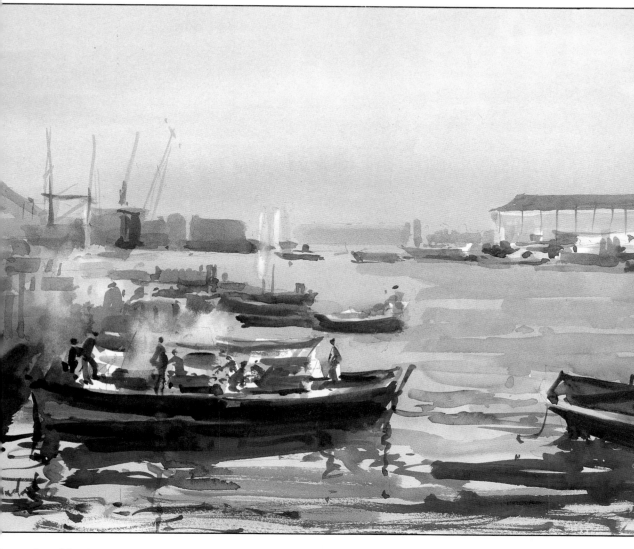

uesada adds zig-zag strokes of Indian ed and cadmium red—warm, vibrating rushstrokes—in the waves closest to his oint of view to create reflections and unterpoints to the figures on the boat. he figures are also strengthened. He ves them life without letting them stand ut too much, without depicting them o clearly, but portraying them in bril-ant synthesis—defined and coloristic in fect despite the limited color range uesada is working with.

any hues, tints, and tones have been eated, imitating the vibration of the er-changing sea. Quesada has achieved ntrasts, balances, and harmonies

through precise calculation. In the reflec-tions of the boats in the foreground, he instills a rhythm through a language of long, direct, broken, and deliberate brushstrokes. But, once again, balance is needed, so he goes back to work on the horizon, darkening it and giving it greater definition. The grayish color of the background remains constant, however, retaining the atmospheric per-spective of the picture. Now, the paint-ing is finished, but not before Quesada cuts off a strip of about an inch (3 cm) from the left-hand side, giving the pic-ture its definitive frame.

Fig. 253. Here is the final result of the process you have been following. The watercolor brilliantly cap-tures the morning light in this seaport, where day-light has scarcely broken and the mists of the night are now beginning to clear. A note on compo-sition: The section of the boat on the right that Quesada painted toward the end accentuates contrast and gives strength to that corner of the picture, adding a di-agonal line to the compo-sition.

Painting a landscape with houses and a beach

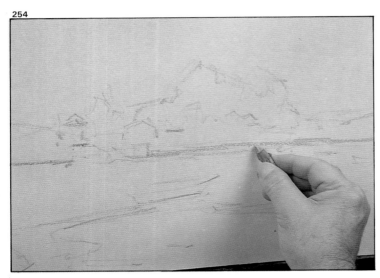

254

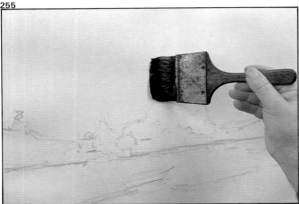

255

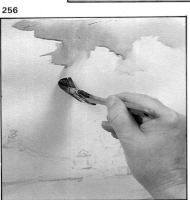

256

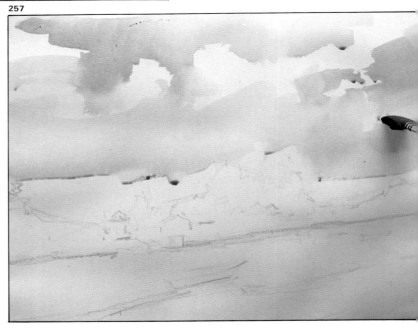

257

For his final watercolor, Quesada is go-ing to paint a landscape with houses and a beach.

He starts by drawing with a blue wax crayon—as always a linear drawing—using as a starting point a thick horizon-tal line, roughly where the horizon will be. From this line and above it, he draws the outline of the trees, hillocks, and roofs of the little houses that form part of his picture. The landscape has in its foreground a beach at low tide, resem-bling a river or canal. Quesada calculates proportions through this linear sketch, trying them out in the air before putting them down on paper.

To wet the paper, he uses a wide flat brush that he sometimes uses to paint large pictures. Mixing viridian and car-mine, he makes a gray for the sky, which he paints while reserving some whites for the clouds. He immediately adds a touch of ultramarine blue and a touch of car-mine to obtain a warmer tone—a blue-gray—which blends perfectly with the previous color.

Fig. 254. Drawing with a light-blue wax crayon, Quesada concentrates specifically on the horizon line—the meet-ing point of land and sea.

Fig. 255. He wets his paper with a broad, flat brush some 3 1/8″ (8 cm) in width. Figs. 256 and 257. Quesada paints the sky with a mixture of viridian and car-mine, using a smaller, though still fairly wide, flat brush. He obtains a blue-gray tone by adding ultramarine blue to the mixture of viridian and carmine; then, af-ter reserving some whites, he continues staining the sky.

Fig. 258. As always, he starts with the large stains of the picture. Now, he turns his attention on to the water, which he paints in the same tones as the sky.

Fig. 259. Next, changing to a smaller round brush, he stains the vegetation and its reflection in the water with a mixture of cobalt blue and burnt sienna.

Fig. 260. Here is the first overall staining of the picture. Tempered colors, bluish and greenish grays, in a composition that reserves most of the paper for the sky.

Having almost finished the sky, Quesada uses the same color mixture for the water, viridian and carmine, a little blue, and plenty of water. He reserves the clear shape of a boat. Then, he changes brushes and creates a warm green tone by mixing cobalt blue and burnt sienna, with which he paints part of the background —the trees and the hills—and the reflection of the hillock in the water. Quesada points out that the colors of the reflections have to be roughly the same as the elements they reflect, lighter or darker if you will, but always in the same color range.

At various points, he accentuates this warm green hue, both in the water and in the earth, by adding cadmium red points that are diluted by the wetness of the paper.

258

259

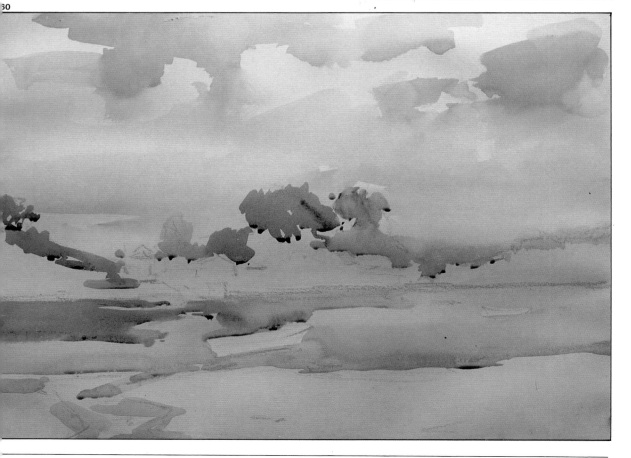

Mixing colors on the pape

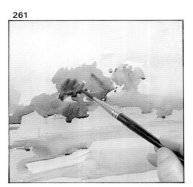

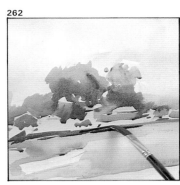

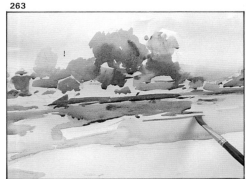

Figs. 261 to 264. To get to the stage shown in Fig. 264, Julio Quesada has stained the area composed of trees, hillocks, and houses. Painting wet on wet with darker, warmer colors, he then moved on to the water area, using the same tones to capture the reflection of the same elements.

Now, Quesada adds more cadmium re and carmine to the houses and to th areas of the picture which he has ju painted green—the trees and hillock c the right. Then, he immediately adds little burnt sienna, which blends in wit the earlier tones to create a vibrant ha mony of colors. With a little of this re mixture, he works on the reflection c the objects he has just painted. Next, h paints a few dark, intense, horizont brushstrokes to separate the land fro the sea and to indicate a shadow and i reflection. As always, in true watercol style, he draws as he paints. And no with the brush held flatly, sideways o he creates new forms with long, fine, zi zagging brushstrokes, which give the se sation of restless rippling water. Virid an is a marvelous color in Quesada opinion, a "wild card" with which gets transparent, atmospheric grays mixing it with reds and siennas.

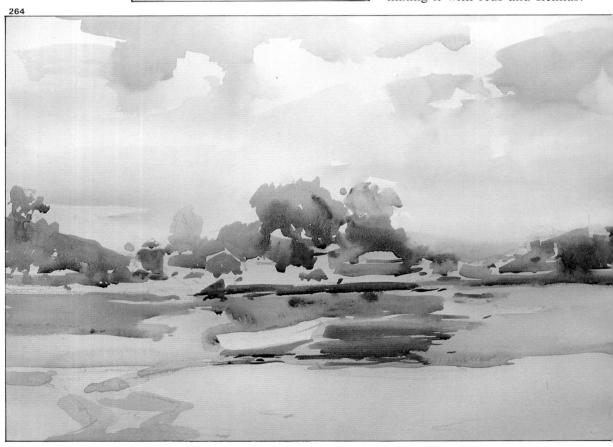

uesada paints with great confidence,
sting his colors on the paper itself. If
is not quite right, he adds another color
r absorbs the color with his brush, un-
l he gets the tone he wants. In this
ainting, he paints the boats, the trees,
d the houses all at the same time with
light violet color. Occasionally, he
aits for the paint to dry a little before
ving a more defining brushstroke. He
aints the sand with a pale, warm color,
lding a definitive and energetic stroke
darker blue to the hill on the left. The
cture is now almost finished; it has an
mospheric, suggestive, and watery ef-
ct which Quesada further accentuates
y using a warm broken color to cover
e earlier colors, except those of the sky.

265

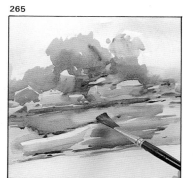

266

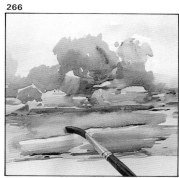

267

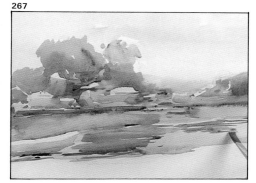

Figs. 265 to 268. Next,
squeezing his brush dry,
Quesada removes paint
from some areas that
made the picture seem
too hard. From these
photographs, you can
see how he has made
the colors more diffused
and harmonious. In this
stage, the reflections in
the water and the appli-
cation of a warm broken
color to the sand in the
foreground have been
begun.

68

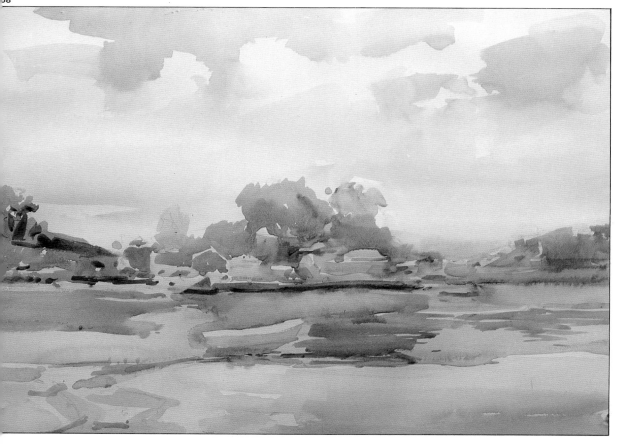

Atmospher

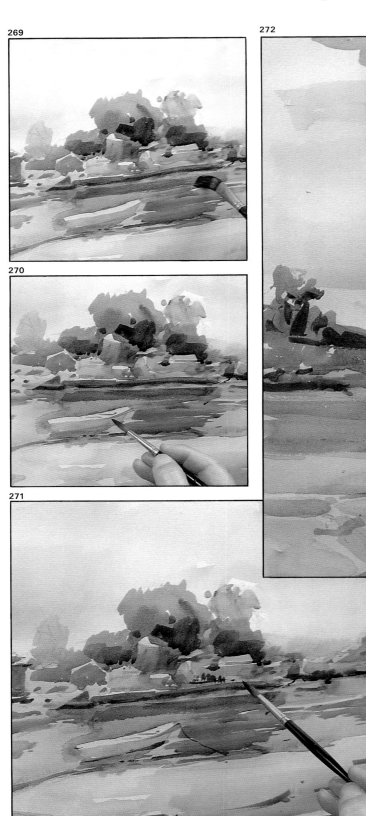

269

270

271

272

Quesada is now ready to resolve the painting. The first thing he does is paint over some white reserves in the left with a bluish tone, especially the part occupied by water. Then, he gives volume to the trees in the center, which were too flat, with very dark, warm green stains and a little ultramarine blue here and there. Before adding the fresh color, Quesada paints a few stains as a test. Then, if he has obtained the color he wants, he allows the paint to spread freely over the paper, or connect with a series of strokes or stains. Sometimes Quesada will use a wet brush to join the strokes or stains. At other times, the wet drops blend with the earlier layer.

A long stroke of blue gives solidity to the central mass of the picture, reinforcing the reflection. Quesada uses this same blue to trace a fine brushstroke on the boat, and then adds a line for the anchor rope.

In these final moments, Quesada continually experiments with colors and movements of the hand, not applying paint until he has reached a decision. He is defining, drawing lines and small details in the land.

As Julio Quesada has worked on the completion of this watercolor, you have been able to see how drawing with a wax crayon, especially with a thick, less-defined stroke, gives greater pictorial quality to a drawing, and, more importantly, gives greater looseness when it comes to painting. Quesada never feels conditioned or constrained by these preliminary lines, he goes beyond them, he blends them into the painting, he does not respect their limits. It is a continuous balance between control and freedom—control of wetness and color, and freedom in the gesture of the brushstroke.

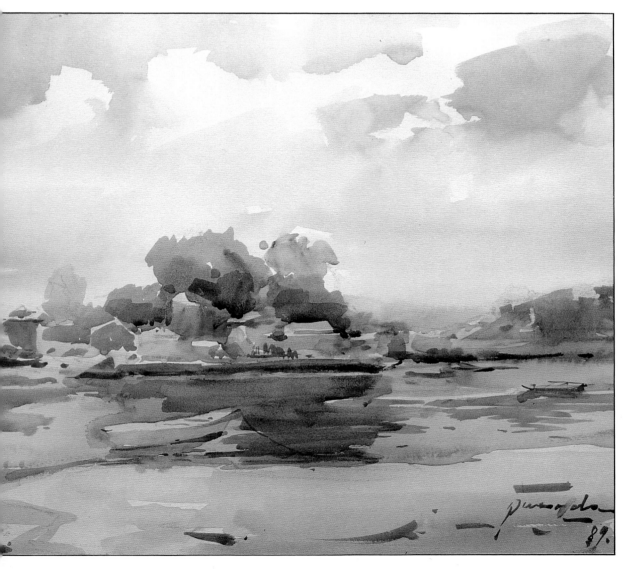

Fig. 269. The artist strengthens the reflection in the center of the picture: First, with a flat brush, he paints a horizontal stroke in phthalo blue; then, as he comes closer to the sand, he adds carmine and sienna.

Figs. 270 and 271. During the last few minutes, or seconds, of the process, Quesada includes some details to add more definition to the boat and to a number of points and lines in the land area.

Fig. 272. Let us carefully admire the completed watercolor, finished with all the freshness and spontaneity typical of the work of Julio Quesada. After absorbing color, a process you saw on the previous page, the artist painted in some shades in the trees, with firm, flat brushstrokes of blue mixed with sienna and green with carmine. Then, with darker colors, he reinforced the separation of water and land, giving the picture more consistency. Finally, he painted in a series of darks in the sand at random, and covered the white areas among the vegetation and in the houses with a light, warm color, so as to leave no holes in the painting. And then he stopped working, for everything had been expressed in the picture.

Acknowledgments

The author acknowledges the cooperation of Fine Arts Master, Muntsa Calbó, for her help in writing this book. He also acknowledges Juan Soto for his graphic work and the firm Piera for their assistance in drawing and painting materials and data.

First published in 1991 in the United States by Watson-Guptill Publications, a division of BPI Communications, Inc., 1515 Broadway, New York, NY 10036.

Library of Congress Cataloging-in-Publication Data

Parramón, José María.
 [Pintando paisajes a la acuarela. English]
 How to paint landscapes / José M. Parramón and Julio Quesada.
 p. cm.—(Watson-Guptill artist's library)
 Translation of: El paisaje a la acuarela.
 ISBN: 0-8230-3656-1 (paperback)
 1. Watercolor painting—Technique. 2. Landscape painting—Technique.
 I. Quesada, Julio 1950. II. Title. III. Series.
 ND2240. P3713 1990
 751.42'2436—dc20 90-12595
 CIP

Distributed in the United Kingdom by Phaidon Press, Ltd.

Manufactured in Spain
Legal Deposit: B-43.943-90

1 2 3 4 5 6 7 8 9 / 95 94 93 92 91